AN EVANGELISM COOKBOOK

## About the Author

Derek Cook is an effective evangelist with over thirty years of pastoral and evangelistic experience. He has worked with Charles Potter in industrial evangelism; with Eric Hutchings, Don Summers, Dick Saunders and Billy Graham in citywide events and as a staff evangelist with the Movement for World EvangelisationTeam and the Filey Week.

He spent six years as a Baptist minister in the industrial North West and a further four years in a country market town in the South. Both churches grew in numbers and in other significant ways under his leadership.

He is now seconded by the Baptist Union of Great Britain to the work of full-time evangelism. He conducts Christian festivals at the invitation of churches of all denominations and trains churches' own evangelists.

# An Evangelism Cookbook

DEREK COOK

Exeter
The Paternoster Press

AUSTRALIA:
*Bookhouse Australia Ltd.,*
*P.O. Box 115, Flemington Markets, NSW 2129*

SOUTH AFRICA:
*Oxford University Press,*
*P.O. Box 1141, Cape Town*

**British Library Cataloguing in Publication Data**

Cook, Derek
An Evangelism cookbook.
1. Christian church. Evangelism
I. Title
269'.2

ISBN 0-85364-479-9

Typeset in Great Britain by
Exe Valley Dataset Ltd, Exeter
and printed for The Paternoster Press,
Paternoster House, 3 Mount Radford Crescent, Exeter, Devon
by Cox & Wyman Ltd., Reading, Berks.

# Foreword

Dear Reader

I have never read a book quite like this. It's unique !

When I began reading I thought it was going to be a simple story of the Miracle at Mouthlock. The story of how Derek and his family have pioneered a training centre in evangelism, and demonstrated what sharing the Good News of Jesus is really all about. As I plunged further into the book I found that I was wrong. Instead of a book about evangelism, one that joins the large number of books available in encouraging us to serve our Lord more directly in witness and sharing our faith, it became a book of 'How to's'.

Here was the information that many of us have longed to see in print. Answers to the simple question of what form an event can take. Who should be involved. How things should be prepared. What specific ingredients are needed. This wasn't just a menu, it was a cook book !

As one who tries from time to time to make a meal for the family, or for friends, I lean greatly on recipes produced by others. I need not only to know the ingredients, but also how to prepare them. What temperature should the cooking take place at, what quantities are needed, how is the meal to be prepared. If you are like me, then the same is needed in preparing an evangelistic event. It's the detailed information that many of us lack. The opportunity of learning from the experience of those who have done it over many many years. This book is therefore a classic first, because it provides not only the recipe, but also the instruction.

Such material could easily come over in a dry and stereotyped fashion. But here are a host of suggestions, attractively produced, and open to all kinds of variation. I want to encourage you to sense Derek's heart in writing this book. His burden for our commitment to evangelism shines through every page. Here is an evangelist from the top of his head to the bottom of his feet, the one who recognises

that none of us find it easy to prepare an evangelistic event. It's to this need that Derek directs his words, and his encouragement is that we might share our faith not only in personal witness, but also in producing opportunities for people to hear the message of Jesus in a more formal – or less formal – setting too.

Perhaps the key to it all lies in our finding Christian friends who will share our vision with us. People with whom we can pray for our non-Christian friends, with whom we can prepare a focal point to which we are all working. In these pages you will find outlined, blow by blow, details relating to advertising, publicity, the form of an event, and the style in which the presentation of the message can take place. You may need to draw in an evangelist from outside to help you in the actual preaching, but that is only a small part of the story. The practical, down to earth, hard-hitting guidance and direction that Derek gives will provide a base from which to adapt his ideas to the context in which you live and work. Never feel you have to slavishly follow every detail. Instead amend and relate each suggestion to your own situation. If you haven't the opportunity to work something through in one particular way, never be afraid to fit it to the vision that you have.

There is one thing, of course, that no cookbook will suggest. Pray over every step. Seek God's face, and do what he shows you to. Use this as a foundation, and the end product will be something – when duly prayed over – that can really be used to God's glory.

I know that it would be Derek's desire that the result of this book will be dozens of better organised, better prepared, and more usable events in God's service. Also a real encouragement to get involved in sharing the Good News of Jesus with people who are waiting to hear just that message.

I hope that you will be as encouraged and thrilled as I have been by the information that is contained here. I hope that you will also pray for Derek and his family in their work for God in Cumbria. I trust that you may write to Derek and share with him some of the news of what happens as a result of your reading this book. It would be wonderful if his postbag was full of letters from people writing to share the good news of how folks have met Jesus as a result of events you have run drawing on the helpful information and support base that he has provided in these pages.

May God bless you in your area, with your friends, to your neighbours, in his way.

Clive Calver
London 1988

This book is dedicated first of all to my wife,
as a tribute to her loyalty, love, support and advice.
Then to Brian, Miran, Ruth and Paul,
who looked after me and entertained me as I wrote,
and thirdly to all the people who have put into practice
the ideas of this book
and have allowed the Lord to bless them
for the extension of his kingdom.

# Contents

# Preface

There was a message on my desk. John Blanchard was ill. He was due to take a series of meetings in Cumbria, starting on Saturday.

I had just returned from a busy week of outreach evangelism and was looking forward to a few days of reading and catching up on the mail, not to mention some time with my family. The call however couldn't be ignored. The Christians in the old county of Westmorland now a part of Cumbria had worked and prayed for a full year for their Crusade. I was the only member of the Movement for World Evangelisation preaching team free and available. Eric Clarke, the team soloist, was also scheduled to go, and he had been there before. He would be the support and help that I needed. So I headed north. In the event, Eric was more than just a support ; he carried the aftermeeting times for the young people in addition to carrying the load of organisation and conducting the meetings in the tent.

Such was my introduction, in 1976, to the old County of Westmorland which I nicknamed 'Wetmoorland'. It was the start of a new phase in ministry for God. It led to the establishment of a Christian Teaching Centre where hundreds have learnt ideas for evangelism.

Chapters 1–5 tell the story of how the Lord guided us and supplied all that we needed to establish the Mouthlock Centre. This experience strengthened our faith. Reading it may strengthen yours.

This book continues the ministry of the Centre. The recipes are tried and tested. I have taken up the cry which I have heard from the lips of so many Christians. 'Don't tell us that we should be doing evangelism. We know that. Tell us *how*.'

CHAPTER 1

# The International Connections

The telegram said that it was from Billy Graham. Of that we had no doubt. It read:

Congratulations as you officially open the Centre. We thank God for your vision and pray that God will richly bless the Centre and the evangelists that come there for training – BILLY GRAHAM

But was it the famous Billy Graham? That was the debate down in the tiny Kirkby Stephen post office. Who were these new people who had come up from the South and renovated an old farmhouse out on the fells near the old Barras station? One person who was in the post office buying stamps had the answer. Her friend knew the new people and was going to open the Centre the very next day...

The date was June 15 1982. Gretta Park, the wife of a local farmer, made a welcoming speech to the seventy or more people who had gathered. Then she turned the key in the lock of the front door to perform the official opening ceremony. So began a work which has linked famous names in the Christian world with the rank and file members of churches of all denominations. The one thing they all have in common is the desire to see the Kingdom of God extended and to learn how to be more effective in evangelism.

The telegrams came in from other church leaders as well. The evangelist Eric Hutchings, prevented from attending by ill health, cabled:

Although regretfully for medical reasons I cannot be with you for official opening of Mouthlock, my greetings and prayers are with you. The Lord grant his seal and blessings on this important occasion. With congratulations and love in his service.

Canon Harry Sutton wrote:

I'm delighted the Teaching Centre is now ready. Every good wish

for a really wonderful day. One of the most urgent needs among Christians in Great Britain today is that they should witness more often concerning the importance of their faith in the Lord Jesus Christ. Many would like to, but do not know what to say. Others know what to say but do not want to say it. I believe the Mouthlock Christian Teaching Centre will help sort out some of these problems and in doing so help an increasing number of people to be effective in their witness for Christ.

Canon David Watson of St. Michael-le-Belfrey York had shown a close interest in the progress of the work. He wrote:
I am sorry not to be with you in person, owing to engagements in Manchester. May God use Mouthlock as a centre for training in bold discipleship. More than ever we need Christians totally committed to Christ, to His Word, to His work and to one another.

In another telegram from the United States Stephen Olford said:
Remembering you on this day of dedication. May the glory of God fill the Centre, the Spirit of God fill your hearts and the blessing of God rest upon your ministry. Haggai chapter two verse seven.

We looked up the verse. It read: '... and I will fill this house with glory, says the Lord Almighty.'

My first introduction to the area had been the tent crusade in Kirkby Stephen. Gretta Park was my hostess for that very first visit and nothing was too much trouble to her or her husband Wilson. The local Christians argued that the farmers of their rural area would be more prepared to attend a Christian meeting that was being held in an agricultural tent than in a church building. They had arranged with the Auction Mart in Kirkby Stephen for the use of a field next to the car park. In fact several local farmers all donated a few bales of hay to compensate for the owners' loss of hay from that field, and a whole band of young men took turns at sleeping in the caravan and making sure that there was no vandalism to the tent during the hours of darkness.

For the end of May, the weather was amazing. One night was so cold that we had to borrow as many Calor gas heaters as possible to try and make the place comfortable. Another night the rain was so heavy that Eric had to turn the loud speaker system up to full

volume to make either of us heard. The next two nights were so warm and bright that we had to let the sides of the tent down for air.

Through it all, the local Christians continued to pray and to invite their friends along to the evenings. With only seven thousand people living within a fifteen-mile radius of Kirkby Stephen it was encouraging to see over two hundred people every night for the nine nights of outreach. My records of the event show the most significant evening was the middle Wednesday. Eric had been in fine form and sang a song about the cross which moved my own heart just before I got up to preach.The Lord used that to lift the preaching. I almost forgot that there was an audience. I was just involved in thanking God for his amazing love. Then there were people moving forward; going down to the side of the tent for counselling, in front of all their friends and in front of people who would say, 'Isn't that the assistant bank manager at Barclays?' It takes a lot of courage to make your response to the Lord when everyone knows who you are.

The local Christians prayed all the harder because I was completely unknown to them as an evangelist. They had invited the 'famous' John Blanchard and they got an unknown. It certainly made them pray more.

Numbers of people were counselled over those days, some for re-dedication and others for personal needs. But amongst those who responded were eleven people of various ages and backgrounds who met with Jesus as their personal Saviour. Some ten years later we were encouraged to know that at least nine of these were actively involved in the work of the Kingdom of God, many of them in leadership positions in the churches that they joined. Mind you, being born again in a tent amid the weather of that week, they were bound to stand firm with the Lord!

So began a link with the area around Kirkby Stephen which was to result, six years later, in our moving from Banstead in Surrey to the fells above Kirkby, answering God's call to set up the Mouthlock Christian Teaching Centre.

Mouthlock? Now there's a name to make you think!

# Hillsides in Cumbria

After that first evangelistic campaign we maintained our links with Cumbria. You only have to visit the Eden Valley to fall in love with it. It doesn't have the same height of mountains as the Lake District but it has a quiet and gentle charm all of its own. The becks and streams can be dried-up beds for days and then suddenly, after rain, they spring into bubbling, joyful life. The curlew call on the fells, the crazy flight of the lapwing when you stray a little too near their nesting areas, and the ever-changing skies make that part of Cumbria a very special place.

A Christian farmer had offered the use of one of his caravans and I was more than happy to take the family at Easter or Whitsuntide almost every year to walk the fells and share in the atmosphere of calm peacefulness.

So began our times of exploration. I remember the time that we discovered Potts' Farm. When we first went there it was inhabited only by rabbits, hundreds of them. Their uncles and aunts lived in the barn or in the nearby fields and skittered away only as we approached. The locals told us that in that part of the valley you could catch enough rabbits to live off them. The old farm-house had been left behind as farms in the area grew in size. Someone had taken over the land but there was no work for the extra family who would have lived in the four bedrooms of the stone house.

We discovered it as we rambled across the open fields belonging to our farmer friend. Suddenly, down in a fold in the land, we saw a building. It had another exit along a mile of bumpy cart-track leading back to a tiny lane and eventually on to Kirkby Stephen. Water would have come from the neighbouring beck, fuel from the woodland, and light, I imagine, from paraffin lamps.

Not that there was any sign of occupation now. We disturbed a

15

bird which had nested in the smallest of the bedrooms and looked out at the racing clouds through a hole in the roof at the top of the stairs. Then we cautiously made our way downstairs again. You sometimes rush into situations without assessing how safe they are and then, when you are inside, you realise that the Lord has kept you safe.

Finding Potts' Farm was only one of many adventures. The family remember enjoying a day at Nine Standards. Do you 'enjoy' being lost?

It was one of those beautiful days that early June can produce. We had often spoken of going up to see the Nine Standards and this had to be the day for it. We didn't plan to go right to the top of the hill, you understand; only part way and then turn back to the car and home to the caravan.

Nine Standards is unique. There they stand, nine turrets of stones on the top of the lonely moorland above Kirkby Stephen. You can see them from the town and from Hartley and from the road over Stainmore. Why are they there? Who took the trouble to collect such an enormous quantity of rock? Who carried it over the peat bog to its present site? Who took time in the wind and rain to build these spirals of stones in dry stone wall technique? Even today some of them are still over fifteen feet in height; in earlier years they may well have been higher still.

The best explanation I have heard has to do with warfare. (Many of our modern inventions seem to be the result of research that was originally intended for military purposes.) The link with the Nine Standards is probably with a battle which the English lost against the marauding Scots. The raiders from the North had made deeper and deeper inroads into the North of England. They were mainly in search of cattle to drive back home although they sometimes also took the crops which had just been gathered.

On a few occasions, it is suggested, the English had sent a force of soldiers to defend the area and their very presence camped up on top of one of the hills had persuaded the raiders to look elsewhere. Viewed from a distance there can be no doubt that the Nine Standards look like a tented encampment. Maybe it was a junior British soldier, tired of freezing to death in Westmorland, who decided to build a tent-shaped pile of stones whilst he nipped down

to Kirkby Stephen for a pint of the local ale and a warm in front of the fire. You can imagine that soon all the ranks, except of course the officer in charge (he may have been trained by the Romans and would still believe in doing his duty to the bitter end) had followed the example and were living the life of luxury in the town. Then the news came through; a special commendation from the general in charge of the whole of the north country and a special award to the Nine Standards battalion for keeping their camp in such good shape during the blizzards. But more than that, a medal because the Scots hadn't tried to attack now for almost a year. The staff sergeant trudged up the hill to tell the commanding officer, only to find that he had frozen to death in the one remaining tent.

I'm not quite sure about the historical accuracy of that account but it does give a colourful reason for the existence of these fascinating piles of stones called the Nine Standards. The nearer you get to them the more you want to see how they are made. That is why we kept on walking on that June day. We did have boots and anoraks just in case it rained but that was the extent of our equipment. We were only going to walk a little way and you could see the Nine Standards quite plainly upon the ridge of the hill. We never planned to walk out of sight of the car; so we took no map, no compass and no chocolate or Kendal mint cake (I left them in the car, you see). I know that *you* wouldn't be as foolish as to set off walking on the fells without those basic commodities!

We had already driven our car to the very end of the passable road. We were up on the fell above Hartley Quarry. We were, in fact, half way to the Nine Standards. The path was a good one and easy to follow. I decided to take the family just as far as the end of the track. But when we got there we were obviously less than a mile from our goal. The dry spell of weather had left the peat soft for walking. You bounced up and down on it and that is just what we did, all the way to the top. The view is good, if not spectacular, but the sense of achievement is immense. We all sat and rested in the glow of conquest.

Now all we had to do was to retrace our steps to the car then home for tea. The strange thing about tracks over a peat bog is that all the paths look the same. You can't tell a footpath from a sheep track and the sheep aren't prepared to tell you the right way. They

watched us with interest as we set off. There was an occasional bleat but I couldn't tell if she was actually saying, 'The car's over there Mister', or merely passing the time of day to be friendly to visitors. We walked long enough to be in a position to see the car but it wasn't there, nor was the road we had driven along. We must have headed down by a different route than the one we took going up. We walked for another three-quarters of an hour to another ridge. There below us lay a road. But we didn't have a map to work out which road it might be and didn't know the lie of the land well enough or we wouldn't have been lost at all. We weren't lost you understand, just exploring on this lovely day. Men don't like to admit that they are lost.

We walked on along the ridge. That was my second mistake. It would have been simpler to get down to the road and ask where we were and maybe get a lift back to the car. But I didn't want to have to ask for help; I wanted to do it my way. In the end I had to go and ask for help. It would have saved a lot of energy and fear if I had done it earlier, but we just walked on and on. Then I had a brilliant idea. Men are good at that sort of thing, especially in an emergency. This wasn't yet an emergency but the time was going and the sun wouldn't last for ever and I did want tea.

I suddenly remembered that you could work out the direction of north by using your watch and the sun. I had learnt to do it years ago in a geography lesson at Burnage Grammar School in Manchester.

I dredged my mind for the correct formula. You pointed the hour hand at the sun, or was it the minute hand? It was a good job I didn't have one of those new digital watches. I eventually worked it out and came up with a near enough magnetic north. We had left our car to the west of Nine Standards so that meant heading back in that direction over there. 'That can't be right,' I reasoned. It would mean that our last hour of walking had been in entirely the wrong direction and we must be more than an hour away from the car. So rather than admit that I had been wrong for so long I re-calculated the position of magnetic north and stubbornly headed off to the south west, entirely the wrong direction again, totally one hundred and eighty degrees out of line. The moorland went on for ever. It began to get darker and quite frankly I was afraid. The family were

getting tired and slowing down but I realised that we had to hurry up before it got dark. There would be no search party. We hadn't told anyone where we were going, we had done it on the spur of the moment. The car was out of sight at the end of a little-used track. We were on our own.

I knew enough about the fells to realise that we needed to head downwards and so, when we found a substantial stream, we followed it downhill. We had to cross it more than once to find any passable walking land and no one was more relieved than I was when we came across some dry-stone walling and then, in the distance, we saw a farm house.

The young farmer's wife had already boiled the kettle and there were cakes on the table to greet us when we hesitantly knocked on the door. She was surprised when we mentioned Nine Standards. We were near Ravenseat; she had assumed that we were walking the Pennine Way and had lost the path and come down to get a bearing on things. Her telephone helped us to reach our farmer friend Wilson Park and an hour later he came to collect us and took us back to our car.

I had learnt again that I wasn't infallible. I had faced again my stubbornness and pride. I had argued that I could cope when I couldn't. I had been too shy to ask for help until forced to do so. But I had met up again with my manhood and I had fallen in love with the fells.

All the same, being in love with the fells doesn't mean that you have to live there all the year round.

CHAPTER 3

# Time to Move

Mouthlock lies on the fells some eight hundred feet above sea level. It is on a little country road linking the Brough to Kirkby Stephen road back to the A66 where it climbs over Stainmore and on to Scotch Corner. Renamed Barras in the 1970s, after the old Barras station, the presence of 'Mouthlock Methodist Chapel' and 'Mouthlock Cottages' and *higher* up the hill the strangely named 'Lower Mouthlock', all bear witness to the fact that Mouthlock was there first. If you want further proof then take a look at the name board as you approach from Kirkby Stephen. Barras is painted on a name board which is suprisingly long for such a short name and at night your car headlights can pick out the 'O C K' of the earlier name that had been painted on the board.

My love for the area and its people, coupled with their growing trust in someone whom they saw every year, led to a further invitation to conduct a time of evangelism on behalf of the local Christians and churches.

This time, at my suggestion, they used several of the local church buildings. The evidence later indicated that just as many 'outsiders' had come or been brought along as when the event had been on neutral ground. It isn't so much where the event is being held but the quality and relevance of the event and the enthusiasm of the 'insiders' which attracts the 'outsiders' to listen to our message.

On the opening night there was a presentation of a Christian musical in the parish church. As I drove over the moor towards Kirkby Stephen, my young musician colleague asked, 'Will many people attend tonight?' He had seen only two farms over the last ten miles and so I could understand his question. Over four hundred turned up. They came from miles around. Every seat was filled and many stood at the back. It was a great evening and the start of an

exciting week. The Baptist chapel was the venue for the evening of Christian films and a late night 'Christian Heavy Rock' event. Heavy, but with words that you could hear, due no doubt to the Tom Jones power of voice of the lead singer. I still remember a show-stopping song about Barabbas. My professional Christian colleague used the Methodist church to present his unique style of music and chat. Local willing helpers turned the church into a theatre for the night and Geoff Shattock's one-man show held the rapt attention of young and old. I believe that one couple did leave in the interval because he had mentioned 'sex' in a song but the message of God's love for lost people got through to everyone else.

Then the final nights of music and proclamation began to reap the harvest. Other things happened as well. Although the ministry was specifically aimed at the non-Christian there were others who came forward in an act of renewal. People put things right in their lives and moved forward with God. Some found that in the quiet moments at the end of the meetings God was meeting with them. I had stressed the indwelling presence of the Holy Spirit who alone makes the presence of the living Jesus real in the believer's life and life-style. Some received a new fulness of the Holy Spirit. A few even found themselves speaking in a language that they had never learnt. One of them put it beautifully when they said, 'When the words of my prayer ran out, I just found myself talking to God.'

It was Thursday tea-time and we planned to finish on the Sunday. I was talking to a farmer friend. 'You'll have to find me a permanent holiday cottage up here,' I said. 'I come so often.'

His reply took me by surprise. 'Why don't you build your Teaching Centre up here? Everything is down in the south of England.'

The thought of having a Teaching Centre had been with us for over two years. It had been one of the driving factors which had led me to leave the position of General Secretary of the Movement for World Evangelisation and set up a separate Trust called Maranatha Ministries.

I had been conscious so often that despite our best attempts to give advice to churches on how to conserve the fruits of an evangelistic effort, those fruits often slipped through the church's fingers. Far too often, the evangelism was all concentrated into one

special week and then everyone went back to normal for the rest of the year or even for five years. If only we could do more for the local churches. If, in addition to taking evangelistic meetings, we could also train the members of the churches to do their own evangelism. Then the work would go on, month by month, and the kingdom of God would be greatly extended. That was our dream. It didn't exactly fit into what the Movement for World Evangelisation committee saw as their future and so with the gracious help of leading members of their Council, men like George Duncan, Dennis Colby and Gilbert Kirby, we set about the formation of an independent ministry trust.

Maranatha Ministries was incorporated on my birthday, July 16th 1977. We started some of our training courses the following year but the dream of having our own building was a long way away. Or so it seemed, until my farmer friend suggested that we think of the north country instead of the Surrey Bible belt.

'Find me a property with ten bedrooms,' I answered, 'and I'll come and have a look at it.' I felt fairly safe. There aren't many ten-bedroomed houses around in any part of the country and most of the larger farmhouses in Cumbria only ran to five bedrooms, so they were out.

Our conversation was held on the Thursday. That evening, unknown to any of us, it was the quarterly meeting of the Methodist Property Board in Manchester. One item on their agenda concerned a property at Mouthlock. The building had started life as a farmhouse; a three-storey house with the cattle occupying the ground floor (an early form of built-in central heating) and then an adjoining barn for all the winter feed to be stored.

But that was before the Revival when the navvies got saved !

# Railways and Bridges

The nineteenth century saw the dawn of the railway age. Through-out Britain new lines were constantly built to supply the needs of industrial expansion. One obvious requirement was a link between Lancashire and Durham; the Lancashire and Durham Light Railway was intended to meet this need, and in particular to assist in taking limestone to the iron works at Durham, from where coke might be brought back towards Lancashire. This was the reason why a branch line was built linking Kirkby Stephen with Barnard Castle.

It involved quite a considerable engineering feat. Apart from the usual stone viaducts the track had to climb Stainmore. Here the line reached what was, for many years, the highest point of any railway in England. To climb Stainmore was going to involve the use of 'double headers'. The trains, pulled by two engines, would steam their way up the hill, but to reduce the gradient a little the line was taken across the Belah river. So Sir Thomas Bouche was called in to design a bridge.

Bouche was later to have his reputation tarnished when his famous Bridge of Tay fell down. It is sometimes forgotten that other engineers all conveniently upgraded their safety figure margins after that collapse. Prior to the Tay Bridge disaster everyone had felt that these margins were sufficient. Bouche's viaduct bridge over the Belah had no problems and stood for a hundred years. It was finally taken down after the Beeching cuts for British Rail in the 1960s. The Belah Viaduct wasn't unsafe in any way; it just had too much scrap metal value. It was a geodetic 'Meccano' construction and double headed trains under full steam must have made a great sight as they crossed it.

The bridge was built and the track laid by hard-working Irish navvies. They lived with the line and moved as it moved on. This

was 1860 and only just in the previous year a revival had swept
through Ireland. Whether some of the workmen had been home for
Christmas and had been influenced by it all, we don't know.

In the Eden Valley revival came through evangelists working with
the Primitive Methodists. Every time the navvies were paid, the pub
owners would turn up with drink for sale. You simply handed over
your money and drank yourself into oblivion. The preachers saw
this as a social evil and as a denial of the men's manhood. So a battle
began; a battle mainly of words, although some of the preachers
were roughly handled from time to time. God won. In one week,
over forty of the Irish navvies turned to God. The ripples of this
movement of God were felt down the valley to Appleby and
beyond. Church records of other denominations recount a special
moving of the Spirit of God in the Eden Valley in 1860–61.

The navvies who were converted looked for a barn where they
could sing their hymns of praise. One of the few buildings visible
from the railway workings would have been our Mouthlock prop-
erty and that is where they came.

Whether the farmer also became a Christian is not clear from the
records which remain, but certainly the barn echoed to the songs of
joy. The old flagstones clattered to the stamping of boots. In fact,
these men were so thrilled about Jesus that they got a nickname.
They became known as 'the jumpers'. When they sang, they became
so excited that they would jump for joy.

Many of them stayed in the area as the line progressed over into
Durham. Some married local girls or got work on the nearby farms.
They also sent out evangelists from their own numbers into the
North West of England. We have the names of fourteen men who
were sent out in this way.

By the end of the century, however, all the fires of the Revival
had died away and many of those original converts had gone home
to glory. Second generation Christians often don't have quite the
same fire; but they did want to keep that presence of God. Their
answer was to build him a building. It is quite beautiful inside but
sadly didn't prevent further decline in the religious life of the area.

For a couple of years, the old farmhouse and barn were used as a
Sunday School but then the new Sunday School was completed and
the premises which had housed the Revival were converted into a

set of cottages. The barn made two small two-bedroomed dwellings. The farm house was a third and an extra part, which had been built on by the converted railwaymen, became a fourth.

Some of the money which the converted railwaymen no longer spent on drink, they used to build a two-bedroomed extension to the farm house. It is easily recognised. It is built in the pink sandstone which the railways used as their facing stones for the bridges, the rest of the farmhouse is in a yellow and buff coloured local stone.

Still more evidence that the extension was not built by local builders comes from the fact than one of the new walls joins the original building directly opposite a window. They had to angle the last bit of wall to join it to the farmhouse again.

The group of cottages became known locally as Mouthlock Cottages and their earlier use as a place of praise and worship was forgotten.

'Find me a property with ten bedrooms', had been my request. The Methodist Property Board meeting in Manchester that evening didn't know how many bedrooms there were in the old set of cottages. Their main concern was the rapidly increasing state of collapse. The roof had finally given way above the part which the railwaymen had added. Window frames were in a dangerous condition. It was only used as a resting place for the occasional tramp passing through and by the Army from Warcop who made it the base for the Reds in an annual exercise on the nearby fells.

The Property Board decided that it would be wise to sell, and to do so quickly before the winter caused more structural damage and left them with a dangerous liability. On Friday morning their officials telephoned the local estate agent. He 'just happened' to be a Christian and 'by chance' had overheard my conversation the previous day. So by four o'clock in the afternoon we were pulling some of the boards off the door and climbing in to see the place.

We just knew that this was to be the Teaching Centre that we had prayed for. No one knew its history as a chapel or anything about the Revival. It was just a set of derelict cottages owned by the Methodists, but we felt a presence of the Lord and a peace even then.

Much more was to happen before we actually made the purchase.

(Like the story of the five pound note, described in chapter 5.) We spent a lot of time in prayer, both with our home fellowship in Surrey and with the local Christians in Cumbria but eventually we owned the place and could begin the work of conversion. We changed the shape of one or two of the rooms by adding new partitions but we didn't change the number. When we found it, there were *ten bedrooms*.

CHAPTER 5

# Gifts to get you Started

Do we really just get what we ask for? I have heard long and heated debates between Christians of various viewpoints about this question. There are certainly several Bible verses which seem to indicate, on a plain reading, that the Lord is just waiting to supply our needs and that the breakdown is in our failure to recognise and verbalise those needs.

I had been up to Cumbria to talk and pray with the local Christians. The Mouthlock property was on the market and we would soon need to make our final offer. The only problem was that there was no money at all in the bank. No special gifts had come our way and income had not exceeded expenditure in the early years of Maranatha Ministries.

I telephoned my wife in Surrey. 'We've had some great times of prayer up here,' I said, 'but no one has yet come along with the first five pound note to help pay for the purchase and renovation of the building.' Lilian reassured me. She was certain that God had it all in hand.

Next morning found me eating breakfast with the Methodist minister in Kirkby Stephen. Bernard Umpleby had been helpful and encouraging in all our meetings and was now giving me hospitality as well. The door bell rang and a lady came into the dining room. 'I feel that I ought to give you a small gift to help you buy Mouthlock' she said. I was very grateful. 'I was going to give you what was left in the housekeeping purse' she continued, ' but I felt that it had to be a very specific amount.' She had been so intrigued that the Lord had told her a special amount that she had checked with her husband who told her that in his prayers that morning he had been told a specific amount as well. So she handed over the five pound note.

That was what I had told my wife was missing, the first five pound note, so that was what arrived, by personal messenger first thing the following morning.

No sooner had she left than the door bell went again. This time it was a young lady on her way to work. The local young people's group had held a meeting the night before and had felt that they should make a gift to help the purchase of Mouthlock. The gift was in cash in the envelope that she handed to me. Again I expressed my thankfulness. When she left I opened the envelope to find a gift of one hundred pounds. It was all in five pound notes. You ask for a five pound note – then that's what you get from the Lord!

With his lovely sense of humour, the Lord crowned the whole episode by telling one couple to take out a Christian covenant payable to Maranatha Ministries to help pay for some of the renovation work. They sent a gift every week for four years. Yes, you've guessed the amount; it was for five pounds a week. I don't think they ever realised just how much their obedience became a learning situation for me. Later in this book we will talk about setting faith targets for your evangelism.

While we are thinking of the Lord's sense of humour what about the name Mouthlock? It is a teaching centre dedicated to the task of helping ordinary Christians talk more about their faith. It is a place where people are taught to open their mouths for Jesus and the Lord chooses an area actually called Mouthlock!

So the *name* is precisely the opposite of what the Centre is all about. It is a learning situation for all those who visit us. We have learnt more about God's creativity as we have sought to share ideas for evangelism with people from all church backgrounds and from every type and size and shape of a church.

In the chapters which follow we present some of the ideas that have been found most helpful by most people. Generally speaking Christians are concerned to reach out with the Christian message to their friends and neighbours. 'Don't tell us that we ought to be involved in evangelism,' they say, ' we know that. Tell us how to do it.' So that is exactly what we have set out to do. These next chapters are about the practical ways of reaching people. We try and talk about the nuts and bolts of it all. Not that love is mechanical but there are certain mechanisms by which love can be made visible.

I believe that our Christian message should be as clearly and as competently presented as any secular message. There are rules of communication which apply whatever the message may be and the Holy Spirit does not make up for our deficiencies when we have been slack in our preparation.

Above all, these are recipes which have *worked*. Time and time again we have received letters describing how a church group or an individual put the ideas into practice and they resulted in the Lord confirming his word, with signs following.

I'm not asking you to put all the ideas into practice at once. I am challenging you to read prayerfully and to be obedient in the issue which the Lord confirms is right for you at this time. There will be at least one idea which you can tackle as an individual. There will be at least one project which you can undertake as a church. This is a call to action. Don't just talk about it, get on and do it. Then to his name will be all the praise and glory.

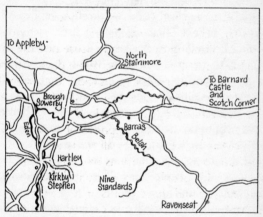

Map of part of Cumbria, showing Kirkby Stephen, Barras/Mouthlock, Nine Standards.

# A Recipe for Evangelism at Home

One of the most effective and exciting possibilities open to you is to use your own home as a base for evangelism. In this chapter I will tell you exactly how to set about the task.

I believe very definitely in church-based evangelism. All of our evangelism needs to stem from the local church situation. The local fellowship of believers is responsible for initiating outreach activity and then for providing the loving care and christian discipling needed by those who become new believers.

Having said that, as clearly and as forcefully as I can, let me add that I do not believe that all evangelistic activity must be church-building centred. Indeed, a very strong case can be made for church premises to be used solely for worship and the teaching of the people of God and never for evangelism. Certainly there is not very much New Testament evidence to support the normal church 'come to us' approach. It really is amazing, therefore, that evangelical churches have continued to use this method over so many years. One is tempted to suspect that they do not really want to reach too many non-Christians so that their internal club structure will not be too much disturbed by newcomers. The New Testament, however, talks clearly about a 'looking for the lost sheep' style of evangelism. Taking that seriously could double our effectiveness overnight.

In recent years, I have often been involved in evangelistic meetings held in the homes of church members. The idea has not been to set up another regular meeting – we attend more than enough of those already – but rather to use several homes to reach those who want to know about the Christian faith but have a barrier about attending events held on church premises.

The ideal pattern is to invite a group of people to your home who will fit comfortably in your living room, so you will have

between eight and fifteen people, counting yourselves. They are invited to listen to a Christian talk about the reality of the Christian faith today. Videos are great for home meetings; people are less threatened by watching the box. Don't show a programme longer than twenty-five minutes, choose a ten to fifteen minute one as the ideal. (Page 103 lists some of the best videos that I have seen with addresses to write to for more information.)

You could use the home of a new Christian or even the home of somebody who is sympathetic but as yet uncommitted. They will often persuade some of their unconverted friends or family to attend with more determination than the established Christians can muster.

Do not, however, make the mistake of thinking that the more non-Christians who come to listen to the 'speaker', the better it will be. The whole idea is to have enough Christians to be able to share in small groups, or one-to-one, before the programme starts and especially at the end. In the video programmes which I have made especially for this style of home evangelism, I ask you to stop the video programme part way through so that one or two of the Christians in the room can briefly tell their own stories about how they met with God.

Choose a time of day suitable to the people invited, whether they need to get home from work or drop children at school. Take care to finish promptly as well and if you announced a finishing time keep to your promise however well the talking is going at that point.

The main advantages of using a home are fairly obvious : the informality of the atmosphere (resist anyone who wants to sing a hymn at the start), the friendliness and ease with which people will talk in a home, the relaxed attitude brought about by the relaxed seating arrangements. All of these factors contribute to a serious hearing of the Gospel message.

From all of our years of experience we are able to discern that the 'success' of such an outreach endeavour depends on three factors:

1.  The prayer concern of the Christians involved.
2.  Careful attention to details.
3.  The willingness of ordinary Christians to share something of their own personal experience of God and his love.

Prayer must be the starting point. There must be a sincerity about your desire to see your friends and neighbours become followers of Jesus. Your depth of concern will grow as you pray for them. You need to be prayerful about which style of meeting to use, which video to hire or buy, and whom you will invite . Then, when you are all excited because the people you have invited have arrived, you need to be prayerful throughout the whole meeting and ready to pray with them or for them when they leave.

Here are some of the DO's and DON'Ts of running an evangelistic home meeting. Take careful note of them; they have all been learned the hard way, by experience.

THE DO's

1   *Invitations*
Prayerfully draw up your list of people to be invited. Aim at a fairly equal mix of Christians and uncommitted people. Use an attractive invitation card. Buy some from W.H.Smith or look at the excellent Christian ones produced by Christian Publicity Organisation (their address is on page 104). The details can be typed or handwritten. Give people about ten days' notice. Ask for a reply and expect it to be 'Yes'. The fact that you have given out an invitation and got an initial reply does not mean that you won't need to remind some or all of them by phone or personal call just before the event. If too many people want to come, hold two smaller meetings.

2   *Timing*
Choose the most convenient time of the day for the target group of guests. If you are meeting in the afternoon and several of the people have young children to collect from school, then 1.45 to 3.00 will be much more relaxed than 2.30 to 3.30. In planning an evening time don't just fix the normal church time of 7.30, especially if your 'fringe' people don't get home from work until late. It is far better to go for an 8.00 or 8.30 start. Be prepared for a midnight finish! The interest will be that great, but remember also to give a clear opportunity for anyone who needs to leave earlier. Some will have arranged a baby sitter or need to set off on a business trip at five the next morning.

## 3 Welcome

Have some gentle background music playing when your guests arrive. This is a real aid to relaxed conversation. It doesn't have to be Christian gospel music. Melodies rather than word songs are the best, otherwise some of your attention is diverted into trying to catch what Amy Grant is singing about. My favourite tapes are the 'String Praise' series.

It is not necessary to introduce each person who arrives to everyone else already in the room. They will only forget the names anyway. Introduce the new person to one other, so that they can start a conversation with someone. Do remember to turn your heating system down or off, a dozen or more people in the average room produces a very adequate amount of heat. Using your home for evangelism can, as a useful by-product, reduce your winter fuel bills.

## 4 Potential interruptions

If some of your guests are young mothers with toddlers, then plan an entirely separate and irresistible entertainment for the children in a different room. Allow time for the toddlers to settle in the home when they arrive, but when you are ready for the talking part, inveigle (i.e. persuade by all means) all of the little ones, and it really must be all of them, into the spare room to play with all the toys and the 'Auntie' who will look after them. It is better to lose an extra mum to the toy room if her child won't part company, than have the little one in for the talk. You can always invite that mum round for coffee on her own another time. Children can be little angels but they can also be little d. . . .s. Toddlers, I have discovered, will sit still and be as good as gold until the crucial moment. Then they will need to sing, or wave, or go to the toilet. If you know of a mum who cannot let go of her baby then invite her to some other kind of event, not to the home evangelism group.

Even worse than interruptions from children are animal interruptions. The dog will sit quietly under the table for ages and then, always at the most important spiritual moment in the meeting, will hear and recognise the dustman coming up the road and be up at the window in a flash, barking loud enough to awaken the dead. The cat will have been asleep all the time, but will choose a moment just

before the end of the talk to leap onto someone's lap, often choosing with amazing accuracy someone who can't stand cats. As for budgerigars, all I can say is, please put them in another room with their night-time cover over them. I assure you that I am not anti-animals except when it comes to evangelism in the home. Export them for the day if you can. Oh yes, remember to unplug the telephone for the hour; the devil can use that as an effective source of interruptions. Can you think of any more potential interruptions? Then please take effective action about them.

## 5  Refreshments
Plan some simple, quickly produced refreshment. Avoid such variety or extravagance as will detract from the purpose of your getting together. If you serve a lot of beautiful cream cakes the people will begin to talk about their diet when you want them to be talking about Jesus.

Usually it is better to serve refreshments at the end, but sometimes it is a good way of breaking down barriers to serve them at the beginning. Your timing will be the key. Coffee is better at 10.30 or 11.00 than at 12 noon. On the other hand, if people arrive at 8.00 in the evening, many will not long have finished their dinner, so they won't welcome refreshments then. Bring in the first tray of coffee and tea without asking for a democratic show of hands on who wants what. If you ask for a vote or count up, you will be providing just the break in the flow of people's thinking that the devil has been aiming at. At worst, you may have something left over, but you will have treated your guests personally as individuals and not as a meeting.

My recommendation for refreshments is to keep them simple and good; home-made biscuits and Gold Blend.

## 6  Personal conversation
Let the invited leader do the leading but be prepared, at the end, to share with the visitors nearest to you. Reinforce and confirm that what has been said is true for you. Don't get side-tracked away from talking about Jesus. In your conversation be positive about Christ rather than negative about other religions or church groups. Take the line of, 'Well, I really don't know much about that, but I do know that Jesus Christ has made a real difference in my life.'

### 7 Literature

Always have some Christian literature available for those who want to know more. A booklet may be sufficient reading as a start but a good paperback book may be right for avid readers and will show them that the Christian faith needs to be thought about, it isn't all contained in a pamphlet. There is a list of suitable material on page 103.

If possible, have an invitation card advertising the next special event; a special film night in the local cinema, a guest service at church, the harvest festival. If there isn't a 'special' planned, there ought to be. People who have listened this time, and want to go away and think about it, will be glad to have a reason to come again. Pray for and prayerfully follow up every single contact made.

## THE DON'TS

1 *Don't* invite people that you do not know at all. Build some bridge of friendship first, even if it is only talking a little about the weather and about your respective families. You can do this as you wait at the school gate for the children to come out, or at the parent/teacher meeting or by sharing some do-it-yourself task together. One way of getting to know a neighbour is to ask, 'Do you possibly have a widget that I could borrow?' A widget is 'a very useful thing for handling the whatsit.' Of course, such an approach puts you at a disadvantage but that is how friendships begin, with you giving yourself away.

2 *Don't* invite known and active members of other religious sects. They will be delighted to come, to try and take the meeting over and turn it into an argument or a platform for their ideas. If you have a burden for someone attached to a false group, then reach them through personal witness, taking a mature Christian friend with you. Don't give them an audience of seeking people in your home.

3 *Don't* put out too many chairs. Have some corners of the room ready where you can slot in an extra chair if extra friends turn up. Adding one extra chair to the room gives the effect of it being

packed to the doors. Having one empty chair encourages people to
spend their time thinking, 'I wonder who hasn't come ?'

4   *Don't* let the Christians that you have invited turn up with big
Bibles under their arms, although pocket sized ones may be very
useful. Avoid anything that creates a 'them' and 'us' situation.

5   *Don't* let all the visitors sit together – or rather, don't let all the
Christians sit together. Take positive steps to prevent this by having
some of your Christians calling for and bringing some of the 'fringe'
people. The welcome with careful introductions will mingle the
group together. At the very least don't leave a whole row of empty
seats. Get some of your Christians there early, space them out with
orders not to move up. In that way, the uncommitted people are
going to have someone to talk to about the faith at the end of the
set talk. It needn't, as I have said, be a talk; it can be an audio/visual
– slide story – film or video programme.

6   *Don't* be shocked by some people's ignorance concerning the
facts of Christianity. We have third generation heathens in Britain
today. Talk about Jesus Christ as Lord and avoid controversial and
irrelevant issues, such as the clothes that the vicar wears for
communion or the doctrine of limited atonement in the writings of
the Puritans!

7   Tell all the Christians, 'From the moment that you arrive, until
after you leave, *don't* stop praying.' If you can, get others to hold a
prayer meeting in their home whilst you run the outreach meeting
in yours.

It has been my joy to see numbers of people really trust Jesus Christ
for salvation at the close of such home meetings, and many more
have come to faith at a later date as a result of first hearing about
Jesus in a home.
Everyone who shows some initial interest or who takes literature in
order to know more, should be personally visited within one week
with something more to read and the offer of prayerful interest and
counsel.

---

USE YOUR HOME FOR THE LORD THIS YEAR.

---

SPECIAL FOOTNOTE

Here's a variation on the theme to use just for men. Yes, you can get non-Christian men to attend and it is easier to do so when you restrict the attendance and make that evening (or daytime) just for men.

Choose a title like 'The happiest day in my life was'... or 'What is a religious fanatic?'

When guests arrive, give them a pen and paper and ask them to write their response to the evening's topic. Unsigned answers are put into a fruit bowl and read out, one by one, by the host. Discussion or laughter or both will follow. At the end the leader briefly reads the answer which the Bible supplies to the topic (See John 1:12, Ecclesiastes 2:26 and Acts 11:26, Acts 15:26 and Acts 17:6.)

Then you serve refreshments; always more substantial when it is a meeting just for men.

CHAPTER 7

# Recipe for a Meal with a Meaning

More people are prepared to accept an invitation to a meal than an invitation to a church service. There is no need to hide the fact that the meal is a 'religious event' and that the after-dinner speaker will be talking about the Christian faith and how it works out today. This ingredient will attract even more people and will result in their having thought seriously about the subject before they arrive on the night of the meal.

Young couples are often attracted to such evenings and if it is really impossible to organise enough baby-sitters then you can hold a ladies' night and a gentlemen's night – but make this your last resort.

Experience has shown that the partners who are the most reluctant to get involved in church things, particularly husbands, are attracted to a 'meal with a meaning'. When sending out invitations, always send to the husband and ask him to bring his wife along to the meal. Don't give the invitation to the Christian wife and ask her to try and drag her non-Christian husband along. Non-Christian men are very sensitive in this area.

Senior citizens can also be invited to their own banquet, possibly at midday, with younger members of the church acting as the waiters and helpers. I know of a newly retired man who had been associated with the Communist party all of his life who got converted after one such event. He came to see this ' community care' which the church was offering to old people. He expected curled sandwiches and strong tea and was amazed at the quality of the meal. All of it was the free gift of the church and this led that man to respond to the free gift of God's love.

Have you ever noticed just how often Jesus used the setting of a meal in order to explain the truth about himself? Start with the

incident in Mark 6. Jesus taught the crowd and then emphasised the truth over a meal of fish and bread. In Luke 7, there is a meal with a Pharisee called Simon. In Luke 19 we read about the little man and the meal that changed his life. You can go on and on, discovering just how often Jesus used the meal with a meaning as one of his main methods of evangelism. The disciples learnt the technique from him and in Matthew 9 the new follower, Matthew, uses this approach as the best way first to share his testimony with his friends and then to introduce the after-dinner speaker – Jesus.

Christians today are slowly realising that some of Jesus' methods are not limited to the first century, but are the basic principles which apply to our present day society as well.With this as their basis, fellowships and churches and other small groups of believers are organising evenings where the meal sets the scene for a relaxed and relevant presentation of the Christian message. Catch the vision for 'a meal with a meaning.'

This chapter will give you all the practical help you need to set up such an event, the effectiveness of which can be hindered by a lack of attention to detail. As with many dishes it is the touch of spice and the special sauce which make a difference to the whole taste.

First of all, you must be clear about your motives. You are not aiming at new recruits to fill the empty seats in your church. You are not planning a happy evening so that Christian friends can get together and enjoy themselves; although that would be a good idea for another evening. Your burden must be to glorify the Lord by sharing the news of personal salvation with your friends and neighbours and interested contacts who are not yet Christians. Although there is only one official after-dinner speaker, each Christian who attends the evening should be ready to speak to non-Christian friends about Jesus.

Work out how many people you can comfortably cater for in the premises that are available to you. I assume that you will use church premises or a suitable large home. If you use your church hall, take the opportunity to have a thorough spring-clean. Use the meal event as your excuse to get rid of stored rubbish, broken chairs, old pianos and discarded playgroup toys. Are there corners of the room to

avoid because of draughts-or can you fix the draught-proofing? A 'meal with a meaning' can improve your premises and reduce your heating bills. Look at your rooms with the eye of an outsider – and redecorate the toilets.

You can hire a local hall and use outside caterers, or book a restaurant for exclusive use one evening. Find which is the low attendance night and negotiate with the manager to give you exclusive use if you bring double his normal number of customers. This, though, increases your costs, for a meal which you could often present better yourselves, and you miss out on all the fun and frustrations of working together on the meal preparation. The secret of success is to delegate the different tasks which need to be done to people who will do them, and to appoint a co-ordinator who will check that everything has been done in good time.

## 1   WHOM SHALL WE INVITE?

The problem will soon become, 'Whom do we leave out?' There are so many people who will be willing to come to the 'meal with a meaning' evening, that you may well find yourselves having to think in terms of having two evenings. Aim at a homogeneous whole. If you have several young married couples invite such couples to the first event. Or invite couples who have teenage children and gear the after-dinner talk to cover the problems that teenagers have with their parents. Have an entirely separate evening for senior citizens, starting and finishing much earlier. Don't mix the senior citizens and the younger age groups for this kind of an outreach; right from the start there will be tension over your finishing time. The young couples will have arranged baby sitters and will have come out for the evening, probably until eleven anyway. The older people will want to be heading back to bed at about nine or nine-thirty.

Plan to have a fifty/fifty mix between Christians and fringe people. At the end of the speechmaking you want Christians to be available to turn to the uncommitted person next to them and talk about Jesus.

Your specially printed invitation cards/tickets need to be available

a month before the event and your catering team need to know the final numbers a few days before the event happens. Fix your number of guests in line with the number of meals which the kitchen facilities make possible. Don't put yourselves under unnecessary strain at this point; you'll only allow the devil to gain a foothold and it's hot enough in the kitchen already.

## 2  BEHIND THE SCENES

Look for someone in the fellowship with professional catering experience. Without meaning to give any offence, I suggest that it is often wise to employ the talent of someone who is not on the Tea Committee and who will not think in terms of past church catering, but will think of the firm's Annual Dinner as the model.

Christian couples ought to be prepared to pay for a non-Christian couple to come as their guests; a £12 ticket for four is a moderate charge to make; in many parts of Britain you pay that per person in a commercial restaurant. If the chef needs more than this amount, subsidise the rest from general church funds.

The kitchen staff must make that work their entire responsibility for the evening and the waiters and waitresses must likewise see their task as one of serving and clearing efficiently and with style. Instruct your staff on how to serve from the left and take from the right, unless unable to do so by conversation between guests, or obstructions. Drinks should be served from the right even to left-handed people. Encourage them to practise serving meals at home correctly. Don't give the Christians the chance to start passing their plates down to the end of the table; collect them correctly from each individual and pray for that person as you do so. The event is to reach people for whom eating out is a familiar part of their lifestyle so we must do it in an acceptable manner.

Don't let your best personal workers act humbly and volunteer to be the waiters and waitresses; you want them to be part of your after-dinner team around the tables. During the talk, please protect your after-dinner speaker from disturbing noises: the washing up, excited waiters letting off steam – also, if you are in a private home, from household pets who decide to wander in and distract the attention of everyone.

## 3   THE WELCOME

You never get a second chance to make a first impression, so your welcome is very important. There must be someone at the door to welcome the guests on behalf of the fellowship. Choose a couple who have the gift of hospitality; people who smile easily are obvious candidates for this job. Have clear signs for cloakrooms and toilets and, if possible, a room where ladies can repair the damage done to their hairstyles by the wind and rain of the evening. It usually seems to rain! Flowers or a Christian banner in the entrance area are an attraction and a conversation starter, as well as small arrangements of flowers on the tables.

Men, in particular, are very lost at such functions if you don't put something into their hands. At a normal business event the non-Christian man would either have a cigarette or a drink to hold. Don't put him under tension right at the start of the evening; give him a glass of special non-alcoholic fruit punch. It is quite reasonable to ask for no smoking and many secular events now have no smoking signs on display, but do give him something to hold. It gives him a certain amount of security and something positive to do with his hands. If you can go to the trouble of 'glazing' the rim of the wine-glass (egg white and sugar) that adds another distinctive touch which makes your event special. I remember talking to one man who had been converted as a result of a 'meal with a meaning' and the item which had made him start to think was that the glasses used for the fruit punch had been glazed. Suddenly he thought,'If these people have gone to all this trouble, then perhaps their message is more important than I realised.' That made him listen more carefully than ever before and he got converted as a result.

Don't leave any empty places at the tables. If some guests have been prevented from coming at the last minute, readjust your table settings just before calling everyone to take their places. Empty seats generate negative conversations about who didn't turn up.

## 4   THE MENU

Menu cards give people something to talk about straight away.

Why not print a Bible verse (use the Good News Version) or some information about the after-dinner speaker?

You ought to be able to offer a simple choice of starters, with the staff asking people individually which they would like. You are setting the scene here for the message which will come later and which says that God cares for each individual.

The main course will probably be a fairly straightforward and universally acceptable dish. Make use of commercially produced items for this course if kitchen facilities are limited. Some groups arrange for several people to bring a cooked casserole and borrow hostess trolleys to keep everything hot. Vegetables are best served in dishes so that people can take as much or as little as they wish.

Serving an apple juice or non-alcoholic wine with the main course can aid digestion and impress the visitor.

Your sweet course could offer a choice of slightly more exotic dishes. A sweet trolley perhaps ?

Then serve the first cup of coffee.

## 5   THE MASTER OF CEREMONIES TOUCH

Whilst not suggesting you go to the expense of hiring an official toast-master, I do recommend that someone acts as Master of Ceremonies. When the guests have all arrived and the kitchen is ready, he can ask people to take their seats at the meal table.

It is a good idea to have place cards and then you can seat your Christian couple alongside or across the table from their guests. Make sure you have the speaker in the best place to be easily seen and heard and that you have seated Christians next to non-Christians. Your tables should not be so wide as to make conversation across them difficult without shouting.

If you have a large hall, don't spread the tables too far apart. Give the waitresses enough room to move around but keep the total group of people close enough to be companionable.

When everybody has found their places, the Master of Ceremonies gives a brief welcome and asks the guest speaker if he will say grace. This gives the speaker an introduction to the audience and allows them to hear the sound of his voice. If your speaker takes

five minutes to say grace, you have chosen the wrong person, start praying. After grace the background music can be played again.

The next duty of the Master of Ceremonies is to gently interrupt when everyone has been served with coffee at the end of the meal and say an appropriate 'thank you' to everyone who has come and who has helped. He then deals with any commercials (do *not* announce all next week's church activities) focusing on the next special event of interest to your guests. He then briefly and warmly introduces the guest speaker.

## 6   THE SPEAKER

A good after-dinner speaker may only talk for ten minutes, or he may talk for forty minutes but in such a way that it only seems like ten.

Without sounding as if he is in a pulpit, he will talk about and illustrate the relevance of the Christian faith for today's generation, and present the basic facts of the Christian message in a way that the fringe person can clearly understand.

At the end he should be able to offer a free copy of a suitable paperback book (you are showing that the Christian faith is a serious and important matter). The speaker should offer the book to those who want to know exactly what is involved in becoming a modern day Christian. Suitable titles are mentioned on page 103.

When the evening finally comes to a close, he should be strategically placed so that people can approach him. He should make a note of people's names and addresses if they request a book, and promise to pray for them. He should also tell them that someone from the church (maybe the person who brought them) will take an interest in them by asking in a week or so if the book has been a help. It is essential that these follow-up calls are made within two weeks. The speaker should also be prepared for personal counsel if it is clear that someone should be led to the Lord there and then. I have often felt it right to end such an after-dinner talk with an actual prayer of commitment. The book is then offered to those 'who prayed the prayer and really meant it'. We have seen numbers of genuine conversions at such evenings.

With or without a prayer – and the guest speaker must sense the guidance of the Holy Spirit in this matter – he should indicate that there are many around the tables who can confirm what he has been talking about. He should then invite people to have a second cup of coffee and to talk some more before leaving. This is the signal for the staff to serve more coffee and the after dinner mints, and for all the Christians to share their own faith and experience with their guests.

## 7  TIMING

If you are planning a 7.45 arrival for an 8.00 or 8.15 meal, then you would expect to reach the after-dinner spot at about 9.30 and the second coffee at 10.00. Quite a number will only leave when you turn off the background music at 11.00. If your evening is for senior citizens (no longer called ' pensioners' but 'prime lifers' by the media people) move everything earlier or you will finish after their normal bed time.

You will be so thrilled with the way in which non-Christians accept the invitation to come, listen avidly to the message, and some who genuinely make a response, that you will immediately want to do as Jesus did with the 'meal with a meaning' idea. He did it more than once. One church has held three such evenings each year for the last ten years. Forty-seven of their present church members came to the Lord through this means of outreach.

You will find that the second meal is much easier to organise and arrange because you have ironed out all the snags in running the first one. Have your second one as a 'dinner by candle-light', or have an evening just for men. Men are so shy about coming to religious events but the combination of food and the face-saving fact that only men can attend this time, will get them there. How about a meal in the function room of your local pub ?

Try an 'international night' and invite all the overseas people in your area, maybe even an international menu. Then there could be one with French cuisine (and a menu in French, *mais certainement.*)

Now here is the really important ingredient. For every such evening you need the backing of the whole church in prayer, even if only a

proportion are involved in the food preparation or the work of bringing people. Possibly two churches can assist each other; one providing the staff for a meal at the second church, and then, at a later date, the second church provides all the helpers needed for a meal at the first church.

Tell people who are being invited that it could be the most important evening of their lives. For some of them, as God the Holy Spirit works, it will be exactly that.

Here is the menu for a recent 'meal with a meaning':

---

### Cream of Cauliflower Soup with Croutons

### Stuffed Peach Savoury

\* \* \*

### Roast Pork with Stuffing

### Roast and New Potatoes
### Carrots, Sweet Corn and Broccoli Spears
### Apple Sauce

\* \* \*

### Apple Pie and Whipped Cream

### Fruit Pavlova

### Cheese Board

\* \* \*

### Coffee and After Eight Mints

---

A SPECIAL IDEA

I have seen some very successful evenings run in people's homes. The numbers attending, of course, are much smaller, maybe only eight or ten. Your dinner party arrangements must be excellent but you will probably not need an official after-dinner speaker, though you may well have a special Christian guest. The conversation will get around to Christianity sooner or later and there will be an opportunity to simply share what the Lord has been doing in your life. Such dinner parties form the pre-evangelism activity which often acts as a bridge; those who attend are then ready to accept an invitation to another Christian event.

ORGANISE AT LEAST ONE MEAL WITH A MEANING THIS YEAR

CHAPTER 8

# Recipe for Reaching the Men

The common complaint that there are two or three times as many
women than men in the church can be traced to the simple fact that
ten times as many meetings are held for women as for men.Why not
change the balance by trying the following possibilities?

Try what I call a 'Face to Face' evening . You run it as a Terry
Wogan-style chat show. You can have just a couple of guests or
three or four. Take the time and make the effort to stage the event
properly. I have seen a number of churches transform their platform
area into a television studio type of format. It can be done very
effectively – though not without effort!

You are going to need a carpeted stage area; also armchairs for
the guests and for your interviewer; a small table with water jug and
glasses – it can get hot under the glare of lights.

Talking about lights – you will need to make changes here. Most
churches are too used to having equal lighting everywhere. I
suppose it is to help us sing all those hymns.If you leave it like that
there will be no focus on the interview and men's minds will wander
to all sorts of other things like, 'What am I doing inside a church?'
So set about the task of transforming the lighting. You may have a
good contact with the local senior school or sixth form college.
They may even be prepared to send some of their students along to
arrange the lighting as an actual project and you can make a gift to
school funds in return. A couple of 'floods' (ie floodlights) will
probably be sufficient.

If your guests are going to sit in a relaxed manner and answer
questions about their jobs and their faith then you will need
microphones to amplify their quiet relaxed answers. Hire some clip
on mikes if you need them. Try out the sound system well before
the night. There is no point in attracting twenty non-Christian men

to attend if they never hear half of what is said. You will obviously have thought about the need to have someone controlling the sound level. Not everyone speaks at the same volume so someone needs to adjust the levels for each particular guest.

So now you have your platform area with effective lighting and a sound system that works. There is only one problem: you can still see the pulpit. I don't want to sound rude but although this is to be a *Christian* event, we don't want it to appear as just a typical religious event. So hide the pulpit. I doubt if the church leaders will allow you to dismantle it altogether but some standing screens will probably give exactly the cover you need. If you have some in the Sunday School, do take down all the kiddies' work before you use them, this is an adult show tonight. If you don't own the right kind of screens to give a backcloth to your stage then the local library might have some to lend you just for the night. That means transport problems. You'll have to ask that non-Christian friend of John's if he'll help you out with the use of his van. It could be just the excuse you need to ask him to come along to the event itself.

Non-Christian men like to help the church out a bit. Don't dismiss it as their attempt to work their way to heaven; treat it as their way of starting to find out how to get to heaven. They are just too shy to come out with that reason at first.

Arrange for some pleasant taped music to be played over the speaker system as people begin to arrive; it helps to set men at ease. There are some lovely *instrumental* praise tapes available. (The words of songs can be a distraction when you simply want background music.)

Your special guest can come from the world of sport or enter-tainment. He may be a policeman, a Christian politician or a well-known local personality. Someone from the building trades or a do-it-yourself expert could also be interviewed. Or how about a doctor, a lawyer or a design engineer? It is particularly helpful if they are willing to discuss a current local or national issue.

There are very few household names that will automatically produce an audience so in a moment we will talk about how to draw the crowd. Concentrate on inviting people who will be able to answer questions about their job and about their personal faith. You

can certainly be just a little controversial if it seems appropriate. You can push the man for example on why he holds his particular position. Do not, however, under any circumstances, open it up for questions from the floor — unless you have Sir Robin Day in the chair that night. Questions from the floor usually centre around some man who likes to hear the sound of his own voice and instead of asking a question, prefers to give a lecture. The other type of questioner has some particular bee in his bonnet and probably no one else wants to know. Invite people who do have questions to meet the speaker at the end of the evening during the refreshment time.

I always recommend that refreshments for a men's evening should be more substantial than dainty. If you are able to organise hot home-made meat and potato pies then I know some men who will be there!

If you watch the chat-shows you will know that they all include a musical break. This is not just to let the musicians have a chance to sing their latest hit, it also gives thinking time and allows things to be set up for the next guest. Your musical break needs to be good. It is also an opportunity to reinforce what has already been said, with a melody message. Don't expect the audience to join in; the old music hall days are long past. In other words don't see the music time as a chance to sing some of the favourite Scripture songs of the day. The new-comer, who is our prime concern, is not familiar with these songs and will be shown to be an outsider if we sing them. The music break is a performance time.

By the way, how comfortable are the seats in your church? Will you have to think seriously about cushions for the front few rows ?

Another possible way of bringing a famous name into your meeting is by means of video. There is the programme 'Mr Speaker' made about the life of the famous Lord Tonypandy. 'A Day in April' tells the story of Police Constable Billy Burns, shot in the head whilst tackling two armed gunmen. 'The Moon and Beyond' is the compelling story of Col. James B. Irwin, the first man to step onto the moon's surface. 'Mine to Share' features the evergreen Cliff Richard. 'Hoddle' is a glimpse into the life and faith of international football star Glenn Hoddle. You wouldn't normally be able to book these men 'live' but the programme can bring them into your

meeting. You can make it 'live' at the end by interviewing one of your own church people who, in a smaller way, is involved in the world of politics or police, modern technology, music or sport.

Men are always interested in new toys so if you do want to have a guest who is on video then use it as the opportunity to demonstrate large screen video in the church.

Think carefully about the skilled task of doing the interviewing. In point of fact it isn't as daunting as it may seem. Someone within the fellowship will have the talent and if he is prepared to work at it he will improve his skills. Remember that there are the Sue Lawleys as well as the Terry Wogans of this world. The interviewer needs as much background information as possible about the people he is to meet. He can formulate his general line of questions before the evening, although he must not be so tied to that direction that he cannot sense the prompting of the Holy Spirit to pursue what has just cropped up in the last answer. Does one of your church members have to do interviews as part of their job ? You might have found the man that you need. Is he willing to rehearse? Not of course with the special guests ( that would remove the spontaneity of the answers) but with other church members. Like a boxer with sparring partners, let it be fun. The men within your church might get to know each other better as a result. Get him to watch the experts on television , male and female. If a show falls on the night of the deacons' meeting then someone will have to video record it for him. No video recorder in the church? Almost half the households in Britain now have a video recorder. Why is the church always behind? Make a quantum leap; get the church a satellite dish.

Given a genuine curiosity about your guests, a certain amount of natural skill and a willingness to work hard, then any articulate man in the church can be your presenter and interviewer in a 'Face to Face' programme.

Now what about getting the men along to the night in question? What is your faith target? A faith target is something over and above what you would normally expect by reasonable human endeavour. For instance, if your church has twenty men who attend fairly frequently, then you ought to be able to get between twenty and thirty to attend a special one-off evening just for men, especially when you mention the pies. A faith target therefore would have to

be an attendance of forty. Of course you could ask for four hundred but I believe that there is a difference between reasonable and unreasonable faith.

Men won't come, however, if they are not invited and can't come if they never hear about it. So we have to spend some time and money on advertising.

Start with small posters in places where men will see them. Small posters are always more acceptable to the owners of the premises where you are asking to display the posters. So where do the men meet? Sports clubs, squash courts and the pubs immediately come to mind. If your guest is from the world of sport, how about an invitation to every local sportsman or if he is from the world of the police, then a visit to the local station (voluntarily of course). If he is a do-it-yourself television personality then display posters in the do-it-yourself shops (together with a personal invite to the shop owners and staff) and also in the television shop.

In themselves posters only create awareness. But they provide the opportunity to give out a personal invitation to a specific person. Have you prayed about who to invite? Have you thought about who you could invite? How many men do you come into contact with during a normal week? Start writing the list down. It will be much longer than you realise: the postman, the man at the petrol station, the men at the garage which services your car, that neighbour, the man in the paper shop, fathers whose children are associated with your church, colleagues at work and so on.

How do you know which ones to invite? Easy, invite them all. As a rule of thumb you will have to invite ten men in order to fill one seat at the 'Face to Face' evening. So if you are aiming at forty that means printing some four hundred invitation cards.

Now for the special secret ingredient: *start praying for men.* Start the hard work of praying specifically for one man to become a believer. Concentrate the prayers of all the fellowship on that one man. Write his name on postcards and make sure that you all carry one to keep on reminding you to pray. When he comes to know Christ let him in on the secret and get him to join you in praying for the next man on the list.

I well remember using that technique in one workplace. After several conversions, a man who was not exactly a communist, but

certainly a fellow traveller, came to one of the Christians and said, 'Please don't put my name on your postcards.'

Sounds silly? All the same,try the recipe. It works.

> START PLANNING YOUR FIRST
> 'FACE TO FACE' MEETING FOR MEN
> **TODAY**

# Recipe for Street Work

I remember watching a television programme of the York Miracle Plays. They had been televised during a performance at the National Theatre and they were sensational. They had laughter and tears, reality and eternity all mixed together in the middle of the crowd. The original performances of those plays in the market places of England must have been powerful events.

It is time to get out on the streets again with our message of Jesus Christ as Saviour and Lord. Remember that many in our generation will not know the basic facts about God and creation or about Jesus and salvation so we will have to spell them out.

Street Theatre is one of the ways to do that. Before you make the excuse that you have no acting skills in your church, let me remind you that several Christian theatre groups have written and published books of their material. Some of them are listed on p.103. Buy the books and I guarantee that you will discover one or two items straight away which you could perform in your local shopping area. If you are nervous, so much the better; it gets the adrenalin flowing and prepares you for the event. If you are very nervous about who might see you then there is a simple cure. Go and give the first performance of your street theatre in a nearby town. You will be less afraid of making a fool of yourself there and once you have held your first performance you will be so excited that you will hardly be able to wait for the next weekend in order to get out on the streets in your own home area.

You will have learnt the lesson that practice makes perfect. Putting it another way — you can't help having butterflies in your stomach but if you rehearse, then at least they fly in formation!

Make sure that your chosen street spot is not private ground, for instance, it may belong to the shopping precinct and not be a public

highway. Ask permission to perform if it is private land. In a public area make sure that you are not causing an obstruction or a public nuisance. Then go ahead. Your brief drama will stop the crowd just for two minutes. You can hand out your publicity, go and have a coffee and come back to do it again. The crowd will be entirely different.

The other excellent form of street work is to use a sketch board. You don't have to be an artistic genius to learn how to do the ladder lettering, where the black brush strokes which you add become the spaces allowing the letters to stand out in colour. Again your talks should aim to hold the crowd just for a few minutes-long enough for your personal workers to spot the interested people and get talking to them at the end of your presentation. One of my team colleagues was out on the shopping area with the sketchboard. ( The police had, in fact, been very helpful and turned a section of road into a pedestrian only area.) One man stood listening as he pretended to look in a shop window. One of the team of Christians approached with a leaflet.

'No, I don't want to know,' said the man, ' give your leaflet to someone else.' But the team member insisted that he took it home so that he would have the details of the meeting that evening in the local Leisure Centre. That evening, who should walk in amongst the early arrivals but the man who didn't want to know! 'I thought I'd just give it a try', he said. He was there again the following night as well and brought his wife and daughter along. All because we first went out on to the streets.

Another effective way of doing street work is the street questionnaire. The aim of the questionnaire is to encourage the person to talk, and from this to lead to a sharing of your personal faith in Christ.

Buy yourself a clipboard to mount the forms on. It makes the survey look so much more official! Most people feel pleased to be asked for their opinions so there is no need to be on the defensive as you approach them. Try this sample introduction-'Excuse me, we're conducting a survey of religious views in this area. Please will you help by answering a few questions, it only takes a few minutes.' If that doesn't work, make up an alternative introduction. Be ready to say that you want the opinions of people who don't believe in

order to make a full survey. Always remember to smile as you approach a person. This is the part of your body language which says that you are friendly.

Don't try and intercept someone who is rushing for a bus or has both hands full of screaming infants. You can soon spot the ones who have a few minutes to spare. Mention that no names or addresses are asked for and very quickly (so that you look efficient) circle Male (M) or Female (F) on your survey form. If you have bought this book then you have my permission to enlarge and photocopy the questionnaire on page 66. If you didn't buy the book please buy one and copy the questionnaire out of your own copy! In the *For office Use* section tick the age bracket which you think the person fits into. Don't ask ages; the boys get embarrassed.

In Questions 3 and 4: *Regularly* means, 'almost every week'; *Occasionally* means 'about once a month' *Rarely* means, 'Christmas Carols, weddings and funerals'; *Never* means what it says!

Don't argue over words. Don't worry over spelling. Don't be shocked by any answers. You are just making a note of people's opinions. Don't add supplementary questions and prolong the interview. If you do, they will have to leave just as you reach the question, 'Would you like to know God better than you do?'

Ideally you should take less than five minutes for the first ten questions.

At the end of question twelve take the opportunity that is given to briefly say how you came to know God in a personal way through Jesus Christ. *SMILE.* Thank them for answering the questions and give them a 'thank you' gift, perhaps one of the Supertracts from Christian Publicity Organisation or Mark's Gospel in the Good News Translation from the Bible Society or one of the Creative Publishing booklets. All the addresses are at the end of this book. Always put a local contact address on your literature in case the person interviewed or a member of the family, wants help some time in the future.

If you are working in the area of your church, include an invitation card to your next special event or to the regular weekly activities.

You should obviously be doing this kind of street work, not only on the shopping areas but at the school gates (interviewing parents)

and door to door in your town. Every hundred homes that you visit will result in about three interested contacts. That is an enormous potential. Too many churches are leaving it for the Jehovah's Witnesses to draw these people into their false teaching. When we go back onto the streets we meet needy people, often at the point of their need. You may make a call on someone who has just lost a loved one in another town. They want to know about the future , they feel mortal. It is a time of great opportunity for faith. You may call on a middle-aged business man who has just been made redundant. He knows that it will be virtually impossible at his age to get another management position. He is asking what life is all about and he has the time to talk about it. It is a God-given opportunity.

MAKE A RESOLUTION **NOW**
TO GO BACK ONTO THE STREETS
WITH GOD

# A SURVEY OF RELIGIOUS VIEWS

|              |                          | Under 18 | ☐ |
|--------------|--------------------------|----------|---|
| For          |                          | 18–25    | ☐ |
| Office  Area | ............................ | 25–59    | ☐ |
| Use          | M ☐  :  F ☐              | Over 60  | ☐ |

1. Do you believe there is a God?     YES/NO/NOT SURE

2. What do you think Christianity is all about? ...........................
   ..................................................................................................

3. Do you attend a church?   REGULARLY......   OCCASIONALLY.....
                              RARELY...............   NEVER .........................

4. Do you read the Bible?    REGULARLY......   OCCASIONALLY.....
                              RARELY...............   NEVER .........................

5.  What do you believe is the real purpose in living?
   ..................................................................................................

6.  What is you ambition in life?
   ..................................................................................................

7. What do you think is the cause of all the unhappiness
   in the world today ?
   ..................................................................................................

8. Do you think there is any life after death ?
   YES/NO/UNCERTAIN

9. Would you call yourself a Christian?
   YES/NO/UNCERTAIN

10. How do people become Christians nowadays? ......................
    ..................................................................................................

11. Why did Jesus Christ die?..............................................................
    ..................................................................................................

12. Would you like to know God better than you do?
    ..................................................................................................

CHAPTER 10

# Recipe for a Christian Festival

The word 'festival' is more often associated with music and with flowers than with the church. A lot of church evangelism has gone under the name of 'Crusade' and 'Mission'. Such names came as a result of wartime exploits and our present generation hardly knows what the words mean or is offended by them. The new name for a Christian outreach is 'Festival'. It is an event which uses a multimedia approach for presenting the gospel.

We will use music and drama, colour and movement. We will use films and interviews, street marches and special events in a blaze of activity which makes the neighbourhood aware that our God reigns.

## WHY HOLD A CHRISTIAN FESTIVAL?

Let me first of all outline the seven undeniable advantages of a Christian Festival and then give you some detailed and practical recipes so that yours will turn out brilliantly for the glory of God.

An ambitious programme of evangelistic outreach will turn your church into a group of *praying people*. Prayer can be a comfortable theory until you come under fire from the enemy; then you really learn how to pray. Don't be content with targets which you think that you can attain. Aim at the miraculous; plan some targets which have to involve the Lord.

For example your advertising budget should be twice what you think you can afford. In that way, it will be good and extensive, modern and eye-catching. You will actually feel that it was worth spending money on it.

Your Festival should include some big spectacular praise celebrations with good production and clear presentation. Present God's

message as powerfully as the world presents its message. Why not launch with a 'Make Way' street march? And don't just think in terms of filling the building with an audience, plan for the television overflow facilities. Ambitious planning of this kind will drive the church members onto their knees in prayer. If the whole thing fails and is a huge flop, then the world will laugh at you – and at the Saviour. 'Lord, you can't allow that to happen. Lord, help us to reach out and make an impact for you, for the sake of your great name.' I have witnessed the marvellous effect there is upon Christians when they really feel that unless the Lord takes over, then there will be a disaster. It is a thrilling experience to see Christians so stretched beyond their human resources that they resort to specific, urgent, passionate prayer.

The second advantage in holding a Festival is that the exciting reaching-out programme will result in a surge of *excitement amongst the members* of the organising church or churches. This will not simply affect the young people, although we do not normally give our Christian teenagers enough to shout about. Why shouldn't they be as excited as a football crowd? It is when Christians are seen to be thrilled with what is happening that more and more non-Christians begin to listen to the message proclaimed. Nothing commends the Christian faith more than the radiant faces of young and old as they get involved in an exciting series of activities.

Soon all the members are being drawn in and involved in some way. Some of your leaders could be the 'think tank' working out how to involve everyone. Others attached to the fellowship will think for themselves of ways in which they can get involved when they see that it is exciting and worthwhile.

The third reason for holding a Festival is that the comprehensive programme of such an event has the beautiful effect of *bringing people together* in the Lord. It has a healing effect. It can deal with old divisions and squabbles by getting the separated parties working alongside each other in the task of presenting the message of salvation to those who are lost. Unity between the people of God is only one of the inevitable by-products of a hectic period of presenting the faith to others. Believers are prone to pettiness when

they are idle. When they are actively involved in Christian service, they stand shoulder to shoulder, as brothers and sisters should, in the army of the Lord. If you are waiting until your church is of one mind before doing any evangelism then let me tell you to start your evangelism right away. Doing so will unite people against the real enemy.

The next reason for a Festival is that it opens up *new possibilities and new horizons* for the church. The ambitious programme of a Christian Festival will entail pushing every possible door of opportunity in the town or district being covered. To the amazement of most churches many of these doors open and opportunities galore are given to the Christians to present their message in the secular realm, including:

Cinemas, Bingo Halls and Working Men's Clubs
Schools and colleges, both maintained and independent
Old people's homes and private early retirement complexes
Young people's centres
Places of commerce and industry, both large and small
Centres for recreation and leisure centres
Football clubs, rowing groups, ramblers and choirs
Townswomen's Guilds

Get hold of a guide to all the organisations in the area. ( Your local Council Office or the Library will be able to help.) Approach all the organisations – yes, all of them. Offer a speaker and a musician who will present something of the relevance of the Christian faith for today, taking five minutes or fifty minutes, whatever they allocate to you.

Push every door that you can think of and then think of some more. Some will open up to you for your Festival, some will stay open to you and your church and others may open at a later date.

The fifth reason for Festival is that it will be the means by which God can *add new members* to your church. You will have been seeing converts from time to time, I am sure, but the Festival gives the chance for a harvest time. The group of new believers will also bring

contact with a whole new group of unconverted friends and neighbours. This new circle of contacts will be watching the changed lives of those who have believed; all of them will be potential additions to your church in your second wave of evangelism.

After one recent festival, one church had a 'New Disciples" group of thirty-one people. Many of these will soon be full members of the church. The festival will have helped the church break through the one hundred membership barrier at which it had been struggling for two years.

Some of the new believers whom the Lord adds to you will be mature people. They will make rapid strides in understanding the faith and in opening their lives to the control of the Lord. New Christians really do know the difference that Christ makes to their lives and they have a greater sense of urgency to tell others. Don't hold them back just because they show up the apathy of some of your older members. Some of the new Christians will have talents and God-given gifts which can be used in the Lord's service. They will have new ideas for old church organisations and structures. Better still, they will have all the enthusiasm and stamina needed for the preparation and presentation of your next Christian festival. You will just praise God for the way in which He works out His plans.

Another thing; a carefully thought out Christian Festival gives you the opportunity to show again that the Christian gospel is a *gospel of power.* You can show how realistic it all is and how it answers the questions of today's generation in their search for reality.

You have the chance to state a thoughtful message which will attract the attention of men. You will be able to present an adult faith and get away from the image that Christianity is just for children. Such a task will involve you in using your minds and the whole activity will result in fitter, healthier, happier, more attractive Christians than you have ever had in your church before.

My final reason for urging you to hold a Christian Festival is that *the effects of a special outreach time last* long after the special series of meetings has ended. The Festival will lift the whole life of the church onto a higher level of expectancy and church growth. The new believers have an influence upon their families and friends, especially in the first year after their own conversion. Concentrate the church's

prayers upon these new contacts. Some of those who responded will have done so by re-dedicating their lives to the Lord. They should be immediately encouraged to move forward with God in some area of their life. Help them to discover their God-given gifts and to use them for God's glory. Probably from this source will come the extra house group leaders that are needed in your church.

Keep the enthusiasm going. Don't be afraid to use one of the new believers as an associate leader in one of the church's organisations. Their enthusiasm will cope with their lack of Bible knowledge and they will be learning all the time.

After a Christian Festival is a good time to teach the concept of tithing to a church. New believers will see this in its true light as obedience to the Lord and your church finances will show an immediate improvement. Some of your people may have been challenged about their area of employment. Be ready to counsel those who now want to get involved in some form of ministry to people; probation service or social care or training for Christian ministry.

The Christian Festival will have also raised your church profile in the town and district. Some people who were invited along but never actually attended the Festival will come to your next special event or at Christmas. Make sure that your publicity reaches them and be ready with the extra seating that will be needed.

I hope that I have created some of the sense of excitement about holding a Festival. Now I want to tell you in practical detail how to mix the ingredients.

PLANNING FOR A CHRISTIAN FESTIVAL

Planning a Christian festival involves discerning the key people.
Key people are always 'possibility thinkers'. Possibility thinkers are Christians who have vision, drive and initiative. Under the guidance and with the power of the Spirit of God, they make the impossible become possible.

Key people do not have to be extroverts but they must be motivators. They must have the God-given ability to enthuse others into tackling the task of evangelism; the gift of encouragement.

Our experience, in over one hundred festivals, indicates that you need five such men or women.

1   **The Prayer Person** – who emphasises the priority of prayer.

2   **The Follow-up Person** – who ensures the adequacy
                                                    of follow-up.
                        .

3   **The Publicity Person** – who makes the Festival newsworthy.

4   **The Resource Person** – who looks after the use of all gifts.

5   **The Co-ordinating Person** – who sees to the smooth running
                                                    of the whole event.

THE PRAYER PERSON – EMPHASIZING THE PRIORITY OF PRAYER

The Prayer Person has a more important job than any of the others. It cannot be stressed too often that prayer is the priority and that prayer brings blessing. Prayer is the key to unlock doors. Organisation can be brilliant but it will be mainly ineffective unless it is all backed by constant, believing prayer.

Appoint someone to this position who has the spiritual gift of prayer. If they, themselves, pray about all the aspects of the Festival, they will know what items to list for others to pray about.

Some of these items can be listed on a printed prayer card. In conjunction with the Publicity Person, the production of a prayer card should be a first priority. Then, start encouraging the believers to pray for a handful of non-Christian friends. Get them to write three names on the back of their Festival Prayer Card and to pray daily for those three. People will come to the Festival meetings when they have been prayed for beforehand.

Learn to make prayer requests visual. Use prayer posters and a prayer items notice board in the church entrance – a piece of pin board with a good heading will do.

Ask as many Christians as possible from other churches to pray

with and for you. A church with one hundred members ought to be able to enrol some five hundred prayer partners merely by including the Christian friends of its membership. Remember to print enough prayer cards to send to all these people.

Send a 'Pulpit Prayer' to all the local churches and ask for it to be used in the month preceding and throughout the Festival. Don't limit your circulation only to the known evangelical churches.

The Prayer Person must be someone who is adaptable. They will attend the church's normal midweek prayer meeting and supply prayer information to this and all other praying groups, such as house groups and ladies' groups who meet on a regular basis.

In addition to encouraging every individual to pray for the Festival daily, the Prayer Person has another vital task; to develop and inspire the corporate aspect of prayer. The New Testament speaks more about praying together than praying as individuals. Appoint, as Prayer Person, someone who can inspire others to pray. Avoid a long-winded person. If you are not careful, it is possible to take up twenty minutes of a thirty minute prayer-time just explaining the items for prayer.

Take up the idea of 'Prayer Triplets'; (See page 103 for details of the book by Brian Mills.) The basic idea is that three Christians meet together each week to pray for each other and for three names suggested by each of them. In one recent festival, of the nine outsiders prayed for by one Prayer Triplet, six attended the meetings and four became Christians.

The Prayer Person must be able to communicate through the written page, so that regular items appear in your church magazine directing Christians to pray. Use these articles to explain the plans for a 'Chain of Prayer', for the Prayer Room during the Festival and for encouraging everyone to start sharing answers to prayer.

Organise a 'Chain of Prayer' for a day about one month before the Festival begins and another such day, if possible, during the Festival itself. Draw up a large prayer chart for the day; from, say, 6am until midnight and ask people to sign in for a fifteen minute period during which they will pray.

During the Festival set up a Prayer Room. Encourage Christians who have not been able to bring a guest to that evening's meeting to stay for a fifteen minute period of prayer at the end of the

evening. Those who have brought a guest will be able to stay with that friend to be available for further discussions, knowing that others are praying.

Throughout the whole period, give out as many details of answered prayer as possible, always respecting people's right to anonymity and privacy. Use the telephone to pass on urgent prayer requests to those whom you know will immediately spend time in prayer. Some of your widows are probably your best prayer warriors.

If your Festival lasts for nine days and Monday is an acknowledged 'bad night' for public meetings in your area, then organise that as a prayer night when the people of God dedicate the week to God in urgent, burdened, united prayer.

Ask individual Christians to be prayer partners for specific people doing particular jobs at a particular time. Keep them informed about the blessings received so that it can be prayer and praise.

Whatever else the church learns through its festival outreach, let it at least learn to pray. Let your church discover that serious prayer will bring the blessing of God.

---

PERSONALITY PROFILE OF THE **Prayer Person**
– WHO EMPHASISES THE PRIORITY OF PRAYER –

Appoint someone with the spiritual gift of prayer:
who is adaptable, can communicate by written word
and who is not long-winded.

Above all, appoint someone who has a burden
to see God's Name glorified.

## THE FOLLOW-UP PERSON – ENSURING THE ADEQUACY OF FOLLOW-UP

After the Prayer Person, the next most important person in the planning team for any Christian festival is the person in charge of the follow-up work.

Follow-up programmes of caring and counselling and discipling must be planned in serious outline before the main programme of a festival is finalised.

Appoint another 'possibility thinker' as your Follow-up Person; choose an optimist, a visionary. Choose someone who is persuasive; able to convince church committees about the need for change; able to inspire people who have 'always done it this way" – or who have 'never done this before' – to try new things in the following up of new believers.

In conjunction with the Resource person, the Follow-up Person will need to gather and train a team of Christian helpers; 'Counsellors' is a strange word for the outsider to hear, usually associated with psychiatrists. The Christian helpers will be responsible for caring for those who make a response during the Festival. Each member of this team will need a basic course or at least a refresher course in caring for new Christians. Although not every Christian in the church is going to be a part of this team of special helpers there is no reason why everyone shouldn't attend the course. Attendance doesn't automatically make them one of the helpers who will be used in the Festival, the leadership may need to use the gift of wisdom in this matter.

The greatest threat to any Christian fellowship which engages in evangelism certainly lies in the area of follow-up, and in the changes to long-established programmes necessary in order to accommodate new believers. It is often just here that church groups become totally resistant to change and their resistance results in the loss of some of the new contacts made. No one advocates change for the sake of change but to expect a new-born Christian baby to attend and immediately fit into the church's routine programme of activities is tantamount to baby battering.

The members of one particular church were very pleased at the end of the special programme of outreach meetings. 'Thank

goodness that's over,' said the spokesman for the church leaders. 'Now we can get back to our normal programme.'

There must be no returning to a 'normal' programme after a festival. 'Normal' will be dated, prescribed and restrictive. 'Normal' will be catering for the established saints not for newly born spiritual babies. 'Normal' will mean pouring any new people into the dull mould of our routine; allowing the church machine to devour them, rather than allowing the Holy Spirit to develop their lives and personalities and give them gifts to use. 'Normal' will almost certainly mean safe and orthodox and middle class. 'Normal' may mean praying in certain set phrases or for an inordinately long time and never expecting any answers to prayer.

The Follow-up Person must have the gift of leadership which will lead the church into fresh, creative thinking in regard to its discipleship training programmes.

The Follow-up Person must immediately take notice of the God-given gifts which new believers possess. Though young in the faith, they are, none the less, functioning members of the Body of Christ. I have seen talented men, leaders in the secular world, become Christians and within weeks take enormous strides forward in Christian maturity. You do not have to wait for five years before giving that sort of a person a job to do, and please make it more than assisting with taking the offering.

In addition to planning the 'one-to-one' nursemaid system of follow-up, organise New Disciples groups. These should be small caring groups, meeting informally in homes. All follow-up Bible studies should be taped or video recorded so that anyone who misses through illness or through business or longstanding prior commitments, does not miss the lesson of the week.

Follow-up teaching should deal with the subjects of Assurance, Temptation, Witness, New lifestyle, Christian worldview, Use of time and money and Discovery of Christian gifts. Those within the church who have the gift of teaching should be used for this work. Remember also that your new Christians are geared to receiving their information through sight and sound channels; be prepared to use every possible means of visual presentation. Do not rely on simply talking at them.

A series of six guest services should be planned to follow the

Festival, at monthly intervals. In this way the new fringe contacts made during the outreach can be followed up. Train your new believers to expect that some of their friends and family will want to come to these guest services. Their faith will be greater than yours in this respect.

Organise another line of follow-up through invitations to meals. One Christian couple invites a new believer home for a meal; the invitation will include the husband or wife if there is one. Whether they are already Christians or not, they will be very interested. Invite a second Christian (or couple) who have something in common with the new believer so that this second couple can invite the new believer(s) along to their home in a couple of weeks time. At this further meal a third Christian (or Christian couple) are introduced and they, in turn, can repeat the invitation. In this way the new believer is introduced to many within the church. They are met in the relaxed and informal atmosphere of a home. The new Christian will grow quickly with this regular opportunity to meet mature Christians and ask questions as they arise. The Resource Person has the task of discovering the gift of hospitality within the Church and the Follow-up Person uses those who have this gift.

A strong argument can be made for appointing *two* key people to the follow-up task. The first one does all the planning and persuading in the months before the Festival. Then, as soon as the Festival ends, a new person takes over with all the energy and freshness that have been reserved for the new believers. This extra person needs to have the spiritual gift of discernment because discovering and using the God-given gifts of the new believers is the area which will lead the church onward in significant, rapid growth.

In follow-up the role of the pastor, minister or full-time Christian worker is crucial. My serious recommendation is that they are released from all routine church duties for the month following the Festival, in order to concentrate on helping with (but not necessarily conducting) the follow-up programme. If they have the gift of teaching, they should be used in the follow-up teaching programme, but the main caring for new-born Christians is the responsibility of the many within the Fellowship, not the one.

Everyone who makes a personal response of any kind during the

special Festival period must be personally followed up within one week of that response. Don't leave seed lying around for the 'birds of the air' to devour.

Your church probably has some unconverted husbands of Christian wives. When the first of these men does get converted, encourage him to talk to the other husbands who haven't yet seen the light. He may not get all the theological jargon right but he will be your best witness to these men.

Some of your new believers may be poor or non-readers. Search for suitable material which they can cope with. Ease the embarrassment that they might feel. Some of your future evangelists to the under-privileged may be in this group. Take a look at the 'Open Secret' teaching notes from Christian Publicity Organisation.

Others amongst your new believers may belong to a different social group from your middle class, suburban church membership. You will have to work very hard to understand them and to translate your 'Daily Telegraph' or 'Independent' language into their 'Daily Mirror' understanding. You may almost need a church within the church to cope with this.

Some of your new believers will be men. Remember that men are more activity-based than word-organised. Can you provide opportunities for the new Christian man to demonstrate his new found faith in actions rather than just by words? It will help him to grow as a believer and attract attention from other men.

In the last resort, follow-up is not really a question of techniques or booklets or study courses. It is a question of time and readjustment and new relationships and it is very costly. If your church or fellowship is to see real growth during the days after a festival then you must pay the price of real follow-up care. Don't let new contacts trickle through the gaps in your church's programme of teaching and loving.

PERSONALITY PROFILE OF THE **Follow-Up Person**
– WHO ENSURES THE ADEQUACY OF FOLLOW-UP –

Appoint someone who sees the vital need for helping the new believers to become disciples.

Appoint someone with the vision to see the new believers integrated into the fellowship of the Church and using their God-given gifts to further extend the Kingdom of God. Consider a second helper to concentrate solely on this area.

Appoint someone with drive and initiative but also with the ability to coax and cajole the Christians into doing new things.

Above all, appoint someone who has a burden to see God's Name glorified.

THE PUBLICITY PERSON – MAKING THE FESTIVAL NEWSWORTHY

However long your Festival period is to be, the fact remains that your church members and adherents, the parents of children who come to your organisations and the folk on and beyond the fringe of the church, will not attend your Festival unless they know that it is happening.

That means that your publicity must be good, attractive,and readable and it must make people want to come. The Festival must appear newsworthy.

Remember that effective publicity for a five-day Festival is almost as expensive as that for twenty-five days. However, in fixing the length of a Festival, you have to take into account the staying power and stamina of your Christians. Many believers are involved in so many areas outside of church life that they either collapse with fatigue after a week of special meetings at the church or so neglect other important duties that they need a month afterwards to catch up. They then go missing during that first crucial month of follow-up work.

Some Christian fellowships can be geared to a concentrated, exciting short festival. Other groups need a whole month of festival, with one or two special events during each week. In this way the joy and anticipation builds up rather than having the Christians turning up on the last day of a nine-day event saying, 'I didn't realise that it had started.'

In a previous section about the Prayer Person, I have already pointed out that people come when Christians have been praying for them specifically. When Christians do pray for others, they discover the God-given opportunities to invite and bring to the Festival those for whom they have been praying.

Whatever the length of the Festival, your publicity is the essential tool which your Christians can use to interest and invite the contacts for whom they have prayed.

For your Publicity Person, appoint someone who has flair: someone who dresses well and has a good sense of colour combination. If you have a publicity expert in the church, then obviously use that person, but make sure that they really do have the talent. Do not automatically appoint the lady who works for the

local printing firm. She may be the tea lady; use her gift in the hospitality area, not publicity.

Do not be afraid to check out the talents of new people who have joined you, male and female. Do not be afraid to use the newly converted advertising representative. Do not avoid young people just because they are young. In the advertising world all the bright ideas come from the under twenty-fives. Of course, you will have to organise their enthusiasm, but they might, with God's help, manage to get your publicity noticed by the secular world. That could be the first time this has ever happened for your church.

It is a good thing to have a logo and a slogan. Whatever identity symbol you use, use it on everything you publish, to give a common identity. The simpler the details, the easier to advertise and publicise. Which is easier to read and remember?—

---

(a)  MAY 1–8

**Every night
at 8pm**

---

(b)  APRIL 27 to MAY 3

**Tuesdays at 8pm
Thursdays at 7:45pm
Saturdays at 7:00pm
Sundays at 11am and 6:30pm**

---

Your publicity should include a general invitation leaflet which, without getting overcrowded, lists all the special events. In addition each special event needs its own separate invitation card so that Christians can be specific about each invitation that they prayerfully give to each friend.

Local shops and the homes of church people can all display a brightly coloured mini-poster; A4 size   (297mm × 210mm) is very acceptable to shop keepers. Cars can have a car sticker, large enough to be seen but not so large that it blocks the visibility out of the rear window. Everyone who displays one should drive carefully, remember that we witness by our deeds as well as by our words! Keep the lettering on these items large and the words few. Use your logo as your identity symbol on everything. I favour bright day-glo colours for posters with bold black lettering to stand out well.

I would expect that between one-third and one-half of your budget for the Festival will be spent on publicity. (See also pages 86f. below).

*Press Publicity*

The Publicity Person should be someone who has contacts with the local press or who will persistently work at developing such contacts. Local newspapers need local colour, and by supplying information about personalities involved in the Festival you will increase the effectiveness of all your other church publicity. Press Releases should always be typed and double-spaced. Leave wide margins for the editor to work in and always put your best bit in your first sentence. If you save it until the end he may have lost interest before he gets to the interesting point. Always type END at the end and give a telephone number. A reporter might want more information or another quote. (Specimen Press Releases appear on Pages 79–81 at the end of this chapter.)

Whenever you can, send the newspaper photographs. You are bound to have a keen photographer in the fellowship; use this God-given ability. A picture is worth a thousand words and both local papers and the Christian press welcome good black and white photographs.

Local radio and the area television station should also be fed with

news and coaxed to do interviews with the famous people who will be sharing in your Festival.

Many towns have free newspapers – mainly carrying advertisements and delivered free to every home. They are widely read and space in such papers is often a good purchase. See if you can get some free space as well, or negotiate a discount rate as a religious project. You will never get 15% off the price unless you ask!

Adverts in local papers should be large. Do not spend your money on six small adverts; go for one big display on the opening day of the Festival. Try and persuade local Christian shopkeepers or business people, who perhaps already advertise in your church magazine, to help finance a half-page advert. The small adverts all mention the sponsor:

```
Mr. R.A. Turner (Insurance Broker)
47, High Street wishes the
Festival God's blessing.
```

Then the middle of the advert gives the details of all the Festival events.

Employ a Christian artist or design agency or the staff of the newspaper itself to draft the layout for you in order to obtain the most impact. You are competing with the professionals and so you must use professional advice.

When you use an outside designer, send him copies of the paper in which you plan to advertise. Study it to see what catches your own eye and then design your material to be eye-catching. When you are buying space, make sure that the paper sets it up how you want it and insist on seeing a layout proof. This may not be easy. It will certainly mean that you need to get your material to them by an earlier date, but you will avoid being disappointed by an advert which fails to provide value for money.

If someone offers to do some free publicity for you, e.g. to put large posters up on poster sites in the town, accept the offer but make sure that you vet the poster design. Better still, pay for professional artwork to be done and include your identity symbol, in order to maximise on the free offer of the sites.

Always check carefully the final proofs of all publicity. If you are not good at proof reading find someone who is. Use someone who hasn't seen the material ten times already: you cannot afford mistakes here. Do not allow any part of your advertising programme to lower the standard of the whole.

Send Press Releases to the Christian press. I have known reports in magazines like *21st Century Christian* and papers like *Evangelism Today* and *Christian Herald* to result in Christians who were moving into an area choosing the Festival church as their church. So advertising and Press Releases have resulted in some growth for the church as people have transferred their membership. At the very least you will gain some prayer support for the Festival. But remember – if you want a news item to appear in the June edition of a monthly, the Press Release needs to arrive during April.

## Other Areas of Publicity

Remember to contact all the local churches, irrespective of denomination or churchmanship. If God has given you blessings you should share them and maybe, in his plan, your festival will lead to some renewal in what you have snobbishly called a "dead" church. Send copies of your prayer poster and several invitation cards for the special events to both the minister and church secretary; this more than doubles the chance of their church members hearing about it. Nearby Christians can then use your special events to bring their unconverted contacts to hear the gospel.

Encourage your own members to contact individuals they know from other churches, by letter or by telephone. You are not interested in sheep stealing, you are aiming to share your blessings. The local library, community and leisure centres often produce monthly hand-outs of forthcoming events. Make sure you are included in these lists: usually the service is free.

Prepare some conveniently sized literature dispensers – a card back with foolscap envelopes cut down to size will work. Fill these with a few of the invitation cards for each of the special Festival events. Such dispensers will often be accepted in shops, doctors' waiting rooms and the local library. One of the banks or a building society may allow you a special Festival display in one of their windows.

A small publicity caravan on a site outside the church, or in the market square, can be a point for distribution of invitation material. Arrange for it to be manned at the busiest times of the day. Cover it with Festival posters and encourage those manning it to prayerfully offer the invitations to those who pass by.

Use 'piggyback advertising': each special event is used to promote and sell the next event.

If you are considering a major house-to-house distribution of publicity, think in terms of making it a distribution of the Gospel of Mark to every home in the area. Include your general publicity hand-out as an insert in the Gospel, or pasted onto the inside back cover. You will have the joy of knowing that you have placed the Word of God into every home. You can then use this Gospel as the basic text for your preaching during the Festival.

Good News Gospels are available from the Bible Society (address on page 104).

In some areas you may decide to use 'News Special', which is produced by Challenge Literature Fellowship. If you use more than 2,000 copies then for a small extra charge you can have a personalised column of local news advertising your Festival. On larger quantities you can also have a complete front page given over to your own event with your heading and even colour photographs, the cost is extra but very good value.

### Timing for Maximum Impact

Christians react much more slowly to advertising material than non-Christians. Christians need maximum information with three weeks to digest it. Non-Christians need to receive maximum impact on the opening day of the Festival itself. So that is the day for your half-page advertisement in the local press; plus your door-to-door leaflet raid; plus all your posters appearing in cars, homes and shop windows. That, at least, is the ideal at which to aim.

We have proved very clearly that people do not just come to meetings; they come to hear people. Do not be afraid to use photographs of the speakers and musicians on your publicity. You are not creating a personality cult but you are allowing personalities to proclaim the truth about Jesus.

Print sufficient publicity material to have some available as the

Festival takes place. There is nothing worse than announcing, 'There's a special event on Tuesday but we've given out all the invitation cards already.' Keep some back for the Festival period or print larger quantities. The rule of thumb is that you need ten invitations to guarantee one person in attendance. Your supply of invitation cards should run out on the last night but one.

## To Church or not to Church

A number of people have asked me if it is better to use neutral public halls for the main outreach meetings of a Festival rather than church buildings. My view is that you have to build a bridge to the church premises sooner or later, so why not right away? This is especially true when the festival is sponsored and supported by one particular church as a part of its growth and witness. Look carefully at your church premises and change anything that has become run-down or dilapidated, replacing out-of-date structures where that is feasible. Please try and remove items which give the impression that church, like a lifeboat, is for women and children only.

If you do have a beautiful new concert hall or leisure centre in your town, then by all means organise some of your events in that venue. There may be non-Christians who have never been inside that building and will come to your event because it gives them a chance to see what the new building is like. They may be surprised by the message as well.

## Still the Publicity Person has not finished

At the end of the Festival give the Christians who have prayed for you the opportunity to praise God with you. Send your reports and photographs to the Christian press. If you have conducted a large number of local opinion polls or street questionnaires then analyse the results and send them to the local press, radio and television. The published results will give the Christians a further opportunity to talk about their faith. Write a final praise article for your church magazine.

Keep your logo, your identity symbol, on all your follow-up publicity for at least six months. Your planning group will have made arrangements for the future and it will be good to maintain continuity in the area of publicity.

A SPECIMEN PRESS RELEASE FOR THE CHRISTIAN PRESS

Send this out about two months before the Festival. Some monthly magazines may need it even before that, check it out.

Double space the lines, leave 2.5cm. (one inch) margins at each side.

PRESS RELEASE                    IMMEDIATE

The Grantham Baptist Church is busy preparing for the Grantham Carnival week in June. They plan to hold a Festival of Faith during that week and will be participating in other carnival events. They have entered a Make Way Float in the Saturday procession. The Festival will be run by the Rev. Derek Cook and a team from Maranatha Ministries which specialises in such events. Included in the week's activity will be street presentations of the Christian message using sketch boards. Two young teachers, Chris and Simon, known as MIMIC, will be demonstrating their faith using mime and music. Other team members will visit local schools to take assemblies and teaching periods. Special evening sessions at the church will include a men's evening and a late night fringe event for young people. The evangelistic team visited the church last weekend to help assist the members in their preparation

END

More details of the Festival of Faith are obtain-able from Maranatha Ministries, Christian Teaching Centre, Barras, Kirkby Stephen, Cumbria, CA17 4ES (Telephone 09304-732)

or from David Palmer : Telephone Grantham . . . . . .

PHOTOGRAPH OF NEWLY RENOVATED CHURCH INCLUDED.

SAMPLE OF PRESS RELEASE FOR SECULAR PRESS

Send this one month before the Festival and follow up with further
Press Releases at weekly intervals.

PRESS RELEASE                              IMMEDIATE

The preparations for the eight day programme of
events for the Festival of Faith, organised by the
Grantham Baptist Church, are now practically com-
plete. The Festival has been planned to coincide with
the Grantham Carnival week from June 21–28.

The team of seven conducting the Festival will be led
by Derek Cook of Maranatha Ministries. Mr.Cook will
speak at the final services on Sunday June 28. A
men's evening is to be held at a local hotel on the
Monday with a buffet supper provided. After supper
they will be addressed by a local businessman. Up to
twenty house-groups will be held on Tuesday and
Wednesday at church members' houses and these
will be open to friends and neighbours. At other
events held at the church, specially invited guests will
be interviewed about their Christian faith and how it
has affected their lives.

Daytime activities will include team members visiting
local secondary schools to speak at assemblies and
teaching sessions. Two young team members, Chris
and Simon, known as MIMIC, will be seen at various
locations in the town centre demonstrating the Christ-
ian faith in mime and song.

END

More information from David Palmer
Tel. Grantham. . . . . .

PHOTOGRAPH OF MIMIC INCLUDED

SAMPLE OF PRESS RELEASE AT THE END OF A FESTIVAL

This was sent out to the Christian Press to encourage those who had prayed and to give glory to the Lord.

PRESS RELEASE                    IMMEDIATE

A tremendous opening weekend set the scene for a week of spiritual warfare in the Bovey Tracey area of Devon. Over twenty people stood, either in rededication or in first time commitment to Jesus Christ on the opening Sunday of the nine day Festival.

During the week that followed, informal home meetings and visits to all the local schools complemented the special events held in the villages around Bovey. Film evenings, Youth Nights and Farmhouse Suppers all reached different people with the Christian message.

It wasn't easy; the evil one attacked in a number of ways, but local Christians prayed for, and saw, many victories. Leader of the nine strong Festival team, Derek Cook, said at the end, 'The local believers now have the important task to carefully follow-up over forty people who have responded to the message of God's love.'

END

More information from Maranatha Ministries,
Christian Teaching Centre, Barras,
Kirkby Stephen,Cumbria CA17 4ES

PERSONALITY PROFILE OF THE **Publicity Person**
— WHO MAKES THE FESTIVAL NEWSWORTHY —

Appoint someone with flair, drive, imagination and good colour sense.

Appoint someone who can be clear and concise.

Appoint someone who has boundless optimism, unlimited patience, and unquenchable persistence.

Above all, appoint someone who has a burden to see God's Name glorified.

## THE RESOURCE PERSON – LOOKING AFTER ALL THE GIFTS

Because this job includes the wise handling of financial resources, the obvious choice is of someone who finds finance figures easy to handle: people in accountancy and banking are highly eligible; but pessimists or misers are not!

The Resource Person has to realise that the Lord supplies generously, through his people, when they are motivated to give for the extension of God's Kingdom.

It goes without saying that the believers should be encouraged to cover all the costs of the Festival before the main Festival begins. This, in itself, will be a testimony to unconverted people. It also means that no collections or offerings need to be taken up during the Festival. I personally believe that 'Thank Offering' boxes should be around during the Festival. If God does speak to believers about giving during the worship of a Festival evening, then they ought to be able to respond immediately in obedience to Him. The extra money contributed can be spent on better follow-up work and go towards more evangelism in the future.

The task of the Resource Person will be to enable each believer to give to God's work. It is his joyful responsibility to help donors

satisfy their need to give, by helping them see the strategic opportunities which the Christian Festival provides.

Don't let anyone get away with saying, 'Couldn't we cut the budget and send the money to help the needy in some Third World area?' The money spent on the promotion, planning, production and publicity of the Festival may well result in the conversion of a business man, who, during his lifetime, will give thirty, sixty or a hundred times the original sum, to help the poorer nations. Cut your budget and you may fail to reach such men.

If Christians can be helped to see the strategic importance of their gifts, they will give. They will also get involved. If they have paid for it beforehand, they will value it when it happens.

Ideally, all of the budget should be covered just at the start of the main programme. Do not be afraid to visit a Christian personally to encourage a substantial gift. A few large donations at the beginning will encourage everyone else to send their gift in order to reach the target.

At one festival we prayed and asked for a tithe — a tenth of the total budget to be donated by the Christians present at the first preparation meeting. The amount needed was four times larger than Mr A, the church treasurer, expected. You can imagine the joy when, at the end of the evening, the believers were told that more than the tenth had been given. Do not appoint a Mr A person as your Resource Person ; the resultant gloom will discourage people from realistic giving.

The main task for the Resource Person is not however in the area of finance. Raising money to pay for all the expenses of a Christian Festival is the least of your problems. The real costs are in the areas of time, love and the readjustments needed within the fellowship to accept the new believers whom the Lord adds to his church.

The Resource Person will be the one who is involved in making wise use of all the other gifts. These certainly include the gift of hospitality. Visiting team members will need accommodation and some events in the Festival programme will need people to provide or serve refreshments at the end of the evening so that there can be an opportunity for informal conversations. It is not the responsibility of the Resource Person to do the catering but it *is* his job to find the people who will do that well and enjoy doing it.

Appoint a separate person to be responsible for the 'Meal with a Meaning' approach if you include that in your festival. The Resource Person will co-operate in suggesting names of suitable helpers, waiters, cloakroom helpers and washers-up.

## Team Needs

Almost all the Christian workers I know would prefer staying in a Christian home rather than in a secular hotel for the duration of a Festival. That does not mean that any and every home is suitable.

If you want the best from your team, then the accommodation is an important factor. Team members usually have a busy schedule to keep to and so a good night's rest is important. Old and lumpy beds can cause irritation and discord and the devil will certainly exploit that to his advantage. Speakers and musicians all need a home where they can be themselves, be treated as one of the family and have time to relax and be quiet.

The best homes are often those of widow ladies who are "given to hospitality" but not to overmuch conversation. I have known a preacher spend so much time chattering to his hostess that he had almost lost his voice when it came to the evening meeting.

Remember that your main Festival meetings are the showpiece and shop-window of your programme. They are occasions when the team must sparkle and be at their best. If team members do not have quiet during some part of the day they will never be able to get into orbit in the evening meeting. Musicians on the team also need facilities to rehearse and practise.

If this makes the meeting sound just a little like a performance then I think that we should honestly admit that it is. We are performing for God. Preaching has been defined as 'truth through personality' and if the personality is jaded, the Holy Spirit will be hindered.

Some evangelists are very careful about food and exercise during a Festival; others need to be encouraged to eat sensibly and do other good things. Big evening meals before the main meetings are not good at all, not even for the best constitution. They draw the blood resources to help the stomach's digestion process when they should all be helping the brain to be alert and make the message clearer.

The team are better catered for by having a light team tea at a central venue. This gives time to deal with any final detailed arrangements. A light meal beforehand may result in starving team members descending on their hostess at midnight for a meal of egg and chips. Do warn the ladies!

In any Festival that lasts longer than a week, some attempt should be made to include a free day or half day. Members of the team should be supplied with details of local beauty spots, famous buildings etc., and gently encouraged to go. As a policy, supply all team members with a town and area street guide. Above all else, team members need to receive special sympathy and to be surrounded by loving prayer.

Line up half a dozen people who will especially pray for each hostess and home where visitors are staying. The devil is bound to want to attack any who are on the front line of the work. The answer is to cover every area with specific prayer. Tell the Prayer Person to arrange this.

## Discover and Delegate

In some areas where public transport is a problem, the Resource Person needs to find an assistant to take over the transport arrangements for all the cars and drivers that can be available during the Festival period. Give priority for the use of transport to those who are bringing family or friends who are not yet Christians. Avoid, however, using all your able-bodied people every night, to bring the very elderly and disabled. Everyone must be available to accompany their own friends. People may also need transport home if they have stayed for Christian help at the end of a Festival evening.

The Resource Person will collect the names and addresses of those who feel that their homes can be used for informal evangelistic meetings (See Chapter 6).

If a literature distribution programme is undertaken, the Resource Person heads up this task and also has the vital job of finding the best stewards to welcome people to the main Festival meetings. If all of this seems too much for one person, then it is. Discover the

talents of leadership in your fellowship and appoint leaders in all six areas:

> Hospitality
> Catering
> Transport
> Use of homes
> Literature distribution
> Stewarding

The Resource Person then leads these leaders, becoming the hub of the wheel of which they are the spokes.

Returning to financial responsibilities, as a rule of thumb, think of one third to one half of your budget being spent on the publicity side of things. You must get your Festival noticed by the outsiders. If you leave it only to the church members to bring their friends then attendances will be low because most long standing church members haven't got any friends outside of the church.

Quality printing is not cheap but it does inspire tremendous confidence in your Christians so that they want to start giving such publicity away to everyone. Remember that you need ten invitations to be given out to fill one seat in a meeting. So if your hall seats 250 and you are having four nights of special meetings you will need a print run of 10,000 to pack the hall.

These are the kind of figures that secular organisations work to and we have found that the attendance for Christian events has been in this same ratio with the amount of publicity. Of course, Christian folk will come with less publicity but the Festival is the opportunity to reach people outside our churches. They cannot come if they do not hear that it is happening. The level of publicity in an area makes it increasingly easy for Christians to invite neighbours because the neighbours will already know about the Festival. Praying harder does not remove the need for publicity.

Ask the Publicity Person to get more than one quotation for your printing costs but remember that the spiritual sensitivity of a Christian firm is worth something in money terms. Do check, however, that the Christian firm has machinery which can produce the quality and quantity you need.

Your budget will include costings for:

Publicity
Press advertising
Preparation meetings
Special events
Literature
Home meetings
Follow-Up
Plus 10% for contingencies

There will also be travel costs and ministry gifts for special guests and team members who will share the whole or part of the Festival period with you. Please treat Christian workers' travel on the same basis as commercial firms or local authorities treat their employees; someone in your fellowship will know the current rate. It will be at least three times the petrol cost.

Try to be as accurate as possible in the budget and allow an element for inflation taking place between draft costings and the actual bills arriving. Each of your *key people* should be involved in the drawing up of the budget so that they can argue for extra money in their department. Once agreed, however, they are not expected to overspend the budget figure.

The raising of the total budget is the task of the Resource Person.

PERSONALITY PROFILE OF THE **Resource Person**
— WHO LOOKS AFTER THE USE OF ALL GIFTS —

Appoint someone who is an encourager and an
enabler: not a pessimist, nor someone who suffers
from small mindedness.

Appoint  a person who finds finance figures
easy to handle.

Appoint someone who really believes that the Lord
does bless happy givers.

Appoint someone who can encourage people to use
the gifts that they have been given by God.

Appoint someone with discernment who is able to
delegate work to others.

Appoint someone with boundless energy but with
the tactfulness needed to lead a team of leaders.

Above all, appoint someone who has a burden
to see God's Name glorified.

THE CO-ORDINATING PERSON — SEEING THAT THE *WHOLE
EVENT RUNS SMOOTHLY*

In football language, the Co-ordinating Person is the 'sweeper' of the
team.

Anything that does not obviously fit into another department,
falls into this one. It is the responsibility of the Co-ordinating Person
to see to it that all other areas of the Festival are being looked after
by someone. It is also their responsibility to see that bright ideas

(even last minute ones) are processed and targets achieved. The Co-ordinating Person needs one special helper. This should be a personal assistant who can type and either take shorthand notes at meetings or do audio-typing.

Whilst it is the task of the Co-ordinating Person to monitor all that is happening they must take care not to become a bottleneck in the system. The other 'key people' act upon their own initiative; they do not have to report to the Co-ordinating Person to ask permission if they can do a certain thing.

When choosing your Co-ordinating Person, look out for somebody with an unflappable personality. If the meetings are held in a marquee, you need the person who can get hold of a new marquee today when the first one has been damaged by a hurricane the night before.

Appoint someone with the ability to weigh up consequences and make incisive decisions. Some of the decisions may turn out to have been less than the best possible, but a delayed decision is always wrong.

Choose someone who can help everyone else to set realistic faith targets. A 'faith target' is a goal beyond the one that you can achieve by ordinary hard work and efficient organisation, but not so unrealistic as to be attainable only in the eternal glory.

Appoint someone who knows how to nag effectively in order to keep things on schedule and on target.

The Co-ordinating Person must encourage each of the key people to gather around themselves a small informal subcommittee of helpers. Delegation of duties involves other Christians in the work of the kingdom and prevents overburdening any one individual. It's hard for a burdened person to do a job well.

The Co-ordinating Person bears a certain amount of pastoral responsibility for the other key people. But do not automatically appoint the pastor to this post: his talents may be needed in other areas.

Decide at the outset whether everyone can come as observers to the general committee meetings – including church members not involved on any informal subcommittee. After all, if they are keen enough to come to committees, you should be able to co-opt them to do something.

There will also have to be times when the key people, plus any full-time ministry people, meet together. The Co-ordinating Person organises these meetings, produces the agenda, takes and circulates minutes and keeps a check on any items that require action. In this way action is taken as soon as possible after a meeting, not as late as possible before the next meeting.

It is essential that all five key people love each other in the Lord and support each other all along the line. Tensions may develop over priorities or procedure. The Co-ordinating Person must see to it that the 'sun does not go down' while they are still angry. '. . . do not give the devil a foothold' (Ephesians 4 : 26–27).

The Co-ordinating Person is responsible for arranging team members' visits to outside meetings – in schools, homes, or local factories, for example. This is where a map of the town becomes essential equipment for every team member.

The Co-ordinating Person also has overall responsibility for the main Proclamation Evenings of the Festival which we will talk about later. The Co-ordinating Person is responsible for organising the opening and closing of the meeting places, and arranging to distribute literature or notice sheets at the door as people arrive. The stewarding team will do the work; the Co-ordinating Person supplies the materials.

The public address system needs to be switched on and checked, the rostrum put in place, background music provided to aid relaxed conversation, the heating system correctly adjusted in winter and adequate ventilation supplied in summer. People must not be so cold that they cannot concentrate nor so warm that they fall asleep.

Pianos will have been tuned before the Festival begins; books for any bookstall ordered and bookstall helpers chosen.

In conjunction with the Caterer, organised by the Resource Person, any refreshments will have been arranged and clear details given in the notice sheet for the evening.

All of these tasks come under the very large umbrella carried by the Co-ordinating Person.

PERSONALITY PROFILE FOR **The Co-ordinating Person**
– WHO SEES TO THE SMOOTH RUNNING OF THE WHOLE EVENT –

Appoint an unflappable person: someone who
gives minute attention to detail.

Appoint someone with great faith: with the
spiritual gift of faith.

Appoint a decision maker.

Appoint a peace maker.

Appoint someone for whom nothing at all is
too much trouble.

Above all, appoint someone who has a burden
to see God's Name glorified.

FESTIVAL PROGRAMME CONTENT

Now we come to the special days of the Festival itself. Most of the
festivals that we conduct run for nine days, covering two weekends
and the time in between.

Many churches discover that within their own organisations there
is a harvest to be reaped. Often it is simply a question of giving
people the opportunity to make a clear response to the gospel that
they have already heard. I am surprised how few opportunities to
respond to Christ have been actually given to those who regularly
attend the Ladies' Hour or the youth organisations in many
churches.

*Church Organisations*
A festival can well begin with an extra week when the visiting
evangelists attend all the regular activities of the church. This will be

an opportunity to meet people in surroundings which are familiar to those people  and from that position to invite them to attend the special proclamation nights of the festival.

## Youth Nights

Using the 'transferred meeting' technique, hold an evening for all the uniformed youth organisations. A transferred meeting means that you do not cancel the normal activity night but you meet, and then go along to the venue of the Festival together. The group meet together at their normal venue or outside the Festival venue and attend as a party.

Encourage everyone to come in their uniforms as normal and reserve sections for the Boys' Brigade, Girls' Brigade, Scouts, Girl Guides. Campaigners, St. John's Ambulance, Sea Cadets and any other uniformed groups that meet in your area. It might be wise to put different groups in different parts of the hall.

Try and use some music by a uniformed group – maybe the Youth Songsters from a Salvation Army citadel. Do not be afraid to introduce an element of competition amongst your youth leaders. 'We have reserved fifty seats for the Scouts' may result in the Boys' Brigade calling up all their reservists to get a turn-out of sixty.

## Ladies

Regular meetings should never be cancelled when a festival is on. The meeting should be transferred to the festival venue. For example, the Young Wives' Group are not to miss their meeting because the Festival is taking place. It is, after all, their regular night out, leaving their husbands to cope with the children and the washing up. They should meet as a group, as usual, and sit together in the main Festival meeting. The Festival then becomes an opportunity to go out on a special trip together, rather than an evening when they cannot meet.

The older Ladies' Fellowship Group might consider holding a special Ladies' Festival Meeting on their usual afternoon but should make it  special  by inviting all the other Ladies' groups within travelling distance.  Use the Festival speakers and musicians in the programme.

*Schools*

Visiting evangelists and musicians could well find a welcome in the local secondary  schools to take assemblies and even lessons.
There are three basic rules for such visits:

1. Only attempt a visit to the local school if you already have contacts there via Christian staff members or Christian pupils. If you go in 'cold' you may produce some interest but who will follow it up when the special visitors have gone ?

2. A gracious approach must be made by a representative of the church, accompanied if possible by one of the evangelists who will work in the schools. The headteacher likes to meet anyone coming into the school. Use one of the preliminary visits of the team for this. Write a letter to the head asking if they will be kind enough to see you. Don't just sit back and wait for a reply, telephone the day after your letter arrives and book the appointment.

    Ask for an appointment at 'ten to ten' , or 'ten to three', just for twenty minutes.  His mind will say, 'If this man's day is scheduled so tightly he won't waste all of my day.' When you meet, your approach should be along these lines: 'We are available as a resource for the School to use, if you would like to utilise the special talents of our Guest team whilst they are in the area.'

    The headteachers of most schools are willing to discuss the possibilities and will then pass on the practical arrangements to other members of the staff. Don't stay longer than your requested twenty minutes, unless you are invited to do so. Remember that you will have to do your 'sales talk' all over again with the staff members who weren't in on your time with the headteacher.

3. The visitors must ensure that, as a result of their visit, the door is open for future teams to visit. It is becoming more difficult for school staff to have special visitors in and give them a free hand to talk about any subject. If those on the Festival team have special knowledge or experience, then the school will

welcome that person to speak on the Christian view of war, drugs, marriage, AIDS. Personal testimony linked to an item on the curriculum will be a unique and valued contribution. The result should always be: 'When you are back in the area, please come and see us again.'

In some Festivals it is possible to stage a first class music concert or drama presentation in an available hall or on the church premises during an afternoon in term time. Then invite the local schools to send a party of their senior pupils to the event. Adequate notice of this must be given, but, as schools like to have a few trips out, it could result in a receptive audience.

*Special Music*
People associate music with festivals; an evening with a Salvation Army band, a visit from a West Indian steel band, a community choir, a folk singer or folk group, special soloists, a male voice choir, a choral society. One or more of these can be incorporated into your Festival programme. If you have some talented singers and a top class accompanist and conductor, then you should think of forming your own Festival Singers and maybe an orchestra just for the Festival period. Such a group can sing on some of the Proclamation nights and could result in a number of your members getting excited about the Festival because they have found themselves involved. In one town that we visited, two teenage girls came to the special evenings because a boy that they liked was singing with the Festival Singers. By the end of the week, the Lord had spoken to them about himself and they had both been converted.

Some music groups are often unfairly criticised because people cannot hear the words that they are singing. Sadly this is sometimes the fault of the acoustics of the church building – church halls are usually even worse. For the best clarity of sound, use a plush hall; one with carpet, soft seats and curtains to absorb reverberation. Remember that high volume does not rule out clarity and that young people are used to picking out the words at that volume.

If you are going to use music groups, you must be prepared to spend some time and money providing a reasonable public address system handled by someone who balances the sound and thus

ensures that the message of the song takes priority over the accompaniment. Choose message orientated groups; groups with something to say, rather than just Christian entertainers.

Make sure also that you invite groups and musicians who have been heard by some of your own fellowship and who are known to exercise their God-given ability to sing in a spiritually discerning and sensitive way. For evangelistic activity choose a group where at least one member  has the gift of the evangelist.

## A word to the Believers

You must ask all your believing Christians to clear their diaries for the days of the Festival. They must see it as their major priority. Given ample warning, most people can rearrange their work load or fix dates for important annual meetings for the week preceding or following the Festival. If your publicity work is successful, and it will be, then a number of non-Christians will attend the public meetings. They will create an alien atmosphere - some of them will have had occult involvement. You need every possible Christian present, every night; even if they haven't managed to bring a non-Christian guest, you still want them there. Spell it out to the believers that their personal commitment is essential.

Please don't be shocked if the non-Christians who attend can't sit through one and a half hours without needing to go to the loo or to go out for a smoke. Stewards should be on hand to direct people to the most convenient places! You could even include a natural break or an interval, part way through the programme, to make it less embarrassing for the visitors.

## Proclamation Nights

Some of your Festival evenings should be clearly planned as evenings when the Christian faith is declared and proclaimed. If it is possible to announce titles in advance, this will give the Christians extra ammunition to use in inviting their friends.

For example, the title for the youth emphasis night could be 'Is there life after birth?' You must remember to spell out the basic facts of Christianity – people do not know that Jesus is 'The Only Son of God'. 'Death and Resurrection', 'The God who will Return' are titles that can spell out the basic truths.

Your Proclamation Nights are going to be a magazine style of programme; fastmoving and varied. But take care not to have so many items   that you squeeze out the preacher at the end. If individual items go overtime then cut out the second song or finish the special interview item earlier.

Your speaker must have sufficient time at the end to make the message clear and invite people to make their response to the Lord Jesus.

The success of your Proclamation evenings will depend upon your attention to detail. Here are some of the ingredients.

(a)   It is important to have music playing when people arrive. Music, at least in the entrance area, or over the sound system of the main auditorium, will draw attention away from any strangeness or embarrassment felt by a visitor.

Put the music quietly back on at the end, or arrange with the pianist/Festival singers/band/orchestra to play for several minutes at the end of the meeting. Choose appropriate material; background music should usually be  instrumental. It can be modern, Christian or classical. Try the Brahms Academic Festival Overture or material from String Praise.

(b)   Organise a welcome by a steward. Choose people who smile easily and readily. Give your stewards name badges to personalise the contact. The first contact with the visitors is far more important than the first words that the evangelist says from the platform, although these are obviously important as well. Remember that people who have travelled may need toilet facilities so have these clearly signposted.

(c)   Make sure that your public address system is adequate. If you have been thinking about replacing it, use the Festival as the excuse for doing the job. Take professional advice. Good microphones are essential; there is no point in having an audience of hundreds if half of them go home without having heard a clear message. If your preacher gave an unclear message you would change your preacher. If the system spoils a clear message then change the system or, at least, hire good equipment for the duration of the Festival. You

ought to be able to find the address of a good local Christian firm of sound engineers.

(d)   Church pianos are such neglected animals. Sometimes they are family pianos handed down over generations and then put out to rest in the church at the end of their life. You may not have an instrument which is up to standard for Festival music and it is only fair to face this fact. At the very least, your piano should be tuned the week or the day before the Festival begins.

(e)   Think about the use of visual aids on Proclamation Nights. Prayerfully and seriously consider the use of short drama pieces, or mime, or dance, bringing in experienced groups from elsewhere if necessary, to act as the catalyst for your own people in the future.

(f)   Old-style testimonies should be replaced with an interview form. This makes it easier to control the time and allows you to use non-speakers who have a good story to tell when someone helps them to tell it.

(g)   Produce a nightly programme sheet giving the news (announcements) together with the complete  hymns and songs to be used in the meeting. Include up-to-date local news where it can be used to underline the Christian message, or items about special guests and how they became Christians. If you know of a good Christian book on the topic for the evening, give that a special write-up. These programmes will be taken home and kept for some time. They will be read by many more people than those who attend the Festival meetings so make them look good and read well.
    Include a name and  telephone contact number or address so that anyone who wants to find faith at a later date can make contact.
    Use a church member who has journalistic talent for this work. If one of your church members who is a secretary can take some days of holiday from work to produce the programme for each day then this will be a valuable contribution.

(h)   At the end of the evening there should be an easily accessible and well signposted Quiet Room where Christian helpers are

available to talk to any who want to respond to the message that they have heard. The evangelist will have his own particular way of giving the invitation to non-Christians to commit their lives to the lordship of Jesus Christ.

An area where coffee and biscuits are served is another useful facility. Fellowship can be continued and contacts involved in further conversation about the faith.

We also recommend that a Prayer Room is available and that, within quarter of an hour of the end of the main meeting that room is in use for a short period of prayer. Christians who didn't manage to bring an unconverted friend but who have seen God at work that evening will pray more fervently for their friends during these prayer times than they have ever prayed in their lives before. Often they return the next evening bringing the friend for whom they have prayed.

TWENTY-FIVE MORE POSSIBILITIES

Once you begin some creative thinking about your Festival you will begin to realise how many other special possibilities there are that can be included in the event.

Ask your five key people to have a think-tank session. Ask them to come up with a list, as big as they can, of doors which can be opened by the Festival. Don't rule out any idea just because, at first, it seems crazy or wildly optimistic. God is great! He isn't restricted to small things.

The following twenty-five possibilities are only briefly outlined just to give you a start for your own personal list:

1. *Visits to local workplaces.* In the smaller workplace you may be able to show a five-minute cartoon video film during a slightly extended tea break. In the larger industries just the walkabout will put your visiting team into the local picture and gain valuable publicity. An initial call on the management will give you an idea of the possibilities in each workplace. Even if they turn down a visit, you've had an opportunity to speak to the management.

2. *Visits to local clubs :*
   Clubs for retired people.
   Day Centres for the elderly or handicapped.
   Working Men's clubs.
   Village social clubs.
   The local play group mums.

3. *The local Bingo Hall.* Approach the manager about allowing your folk singer time to sing a song before play restarts after the interval. They might ask for an encore.

4. *Cinema.* Can you get a free advert inserted into the Forthcoming Attractions leaflet? Or a mention of your Youth Night? Will the manager include a religious film in his programming before or after your Festival?

5. Book a good hotel for a *Business Men's Lunch* or *Breakfast.* Get the local Mayor, or Member of Parliament, to act as chairman and have a couple of witty and brief after-lunch speakers who will talk about the Good News.

6. Put on *an exhibition of the history of the church* in the local library's exhibition entrance area.

7. Try a *'Bible Comes Alive'* exhibition for a week in the lead-up to the Festival.

8. *Tearcraft or Traidcraft* can provide a valuable contribution. Purchase and sell their goods. This gives an opportunity to express care for the Third World. (See p. 104 for addresses).

9. *A Christian bookstall* also makes a useful addition to the total impact. Review one book on your nightly programme sheet. If you have a local Christian colporteur or Christian bookshop they will probably run this stall for you.

10. *Lunchtime talks or music recitals,* Lunchtime Drama Workshops or gospel concerts.... Not everything has to happen in the evenings.

11.   *Street theatre.* You may have more local talent than you ever realised. Even a sandwich-board parade with positive and colourful posters can be effective.

12.   *Open Air sketch board* on the local shopping precinct. Don't use high-powered public address equipment which keeps people at a distance, draw them in close and have your publicity ready.

13.   *Special flower arrangements* on display in the local church or churches as part of the Festival. Have flower pictures of Gospel incidents, with an open Bible underneath to give the passage to read. Does the local council do a flower picture in one of the borders of the local park ? Can it say Festival?

14.   *An Exhibition of Christian art:* Crafts – Sculpture – Photography etc.

15.   *A missionary exhibition* showing the work of various Christian organisations in one particular part of the world. Stage the exhibition in the church hall. Get the local  schools to take an interest and to send groups of children along. Get them to do a project on the part of the world which is featured. A full list of missionary societies is contained in the World Mission Handbook available from the Evangelical Alliance. Details will also be found in the U.K. Christian Handbook.

16.   *Street Questionnaires.* Ask people for their opinions about God and the meaning of life. Results should be properly analysed and submitted to the local press and radio station. In some places, questionnaire results have made the headlines on the front pages.

17.   *An enquiry shop or caravan* parked in an area which people pass daily can become a centre for publicity distribution and even a counselling centre. People involved in staffing this will generally need to go to the passers-by with the literature and not just wait to be approached.

18.   *A competition for children* – painting or poetry or hymn-

writing. Again make your approach to the schools for entries. Offer a prize, say £10 to the individual winner plus £30 to the funds of the winning school.

19.  *Student events.* If there are overseas students in the area, organise an International Night with food from various countries.

20.  *Special Festival services* – your guest team members can conduct Festival Services on the Sunday in the church or other local churches.

21.  *A Festival Fun Run.*

22.  *Late night Festival Fringe* meeting using your drama or music group, 11pm until midnight.

23.  *Free plastic carrier bags* advertising the Festival distributed via all the local shops. Addresses for suppliers of such items (and balloons and pens) can be found in the pages of *Exchange and Mart*.

24.  *Open-air reading* or writing of the whole of the New Testament.

25.  *Telephone* people in your area to tell them about the Festival. This is in effect a sort of door knocking without going to the door. This approach is surprisingly well received.

Plus anything else that any inspired individual, or group in the church feels able to contribute to the whole Festival. Each event will give special opportunities in its own right and will add to the publicity for, and general interest in, the main Festival programme. Remember to keep your aims clear: don't encourage children to come to an event planned for adults; don't bring in all the elderly invalids to a programme planned for reaching men or young couples. By all means do have other events for those needy people. I haven't said very much about childrens' work and that is deliberate. An outreach to children is a very specialised project. Whole books have been written about it. I believe that such work should be done

at an entirely different time from when you hold your Festival. The emphasis in your Festival should be that the Christian message is for adults, especially for men.

Do cover everything with prayer so that all that is done brings glory to God.

## TO ENCOURAGE YOU

I believe that the rest of this century will prove to be a tremendous period of growth for the churches of the United Kingdom.

Evangelism that is Christ-centred and based on the local church will be essential for that growth.

There is a religious surge and a religious search going on in our land. So the time has come for Christians to emerge from behind their closed doors as Spirit-filled men and women, proclaiming their faith in a risen Lord Jesus who can save people today.

Christian believers should show their joy and exuberance.
Christian believers should reveal the release of their praise.
Christian believers should demonstrate the excitement of their faith.

When these things are done prayerfully, ambitiously and under the direction of the Spirit of God, then you have a Christian Festival.

Such a Festival will result in friends, family members and neighbours being brought into the Kingdom of God.

If you have a burden to bring glory to the name of the Lord, then take up some of the tried and tested recipes for evangelism contained in this book. Put them into practice in your area: as an individual or as a church fellowship. God will honour your endeavour.

'Whatever you do, do it all for the glory of God'
(I Corinthians 10:31 ).

# Useful Books

*Evangelistic books:*
'The Case against Christ'  *John Young* ( Hodder & Stoughton)
'Finding Faith'  *Andrew Knowles* ( Lion)
'Finding God'  *James Jones* ( Darton Longman & Todd)
'Is Anyone There?'  *David Watson* ( Hodder & Stoughton)
'It's Friday, but Sunday's Comin' '  *Tony Campolo* ( Word)
'Your Verdict'  *Val Grieve* ( STL IVP)
'Now believe Now' (booklet)  *Derek Cook* (Maranatha Ministries)

*About Prayer Triplets:*
'Three times Three equals Twelve' *Brian Mills* ( Kingsway)

*Drama :*
'One Stage Further'  *Nigel Forde* ( Kingsway)
'Back to Back's little Black Book' *Fraser Grace* ( Kingsway)
'Red Letter Days' *Burbridge & Watts* ( Hodder & Stoughton)
'Time to Act'  *Burbridge & Watts* ( Hodder & Stoughton)
'Scene One'  *Ashley Martin, Andy Kelso and others* ( Kingsway)

*Songs*
'Make Way Songbook'  *Graham Kendrick* ( Kingsway)
'Make Way Songbook Two'  *Graham Kendrick* ( Kingsway)

*Videos*
*Mr. Speaker: A Day in April: The Moon and Beyond: Mine to Share: Screen Test*  are all available from or produced by CTVC, Beeson's Yard, Bury Lane, Rickmansworth, Herts WD3 1DS
*Better Get Ready* and *Journey Into Life* are available from
Sunrise Video, P.O. Box 814, Worthing, West Sussex, BN11 1TS
*Philip and the Television Set* and *How much are we Worth?* are available from Maranatha Ministries.
Many Christian videos are available for hire from:
International Films,  235 Shaftesbury Avenue, London WC2H 8EL

# Useful Addresses

CHRISTIAN NEWSPAPERS/MAGAZINES
*21st Century Christian* – 37 Elm Road, New Malden, Surrey KT3 3HB
*Christian Herald* – 96 Dominion Road, Worthing, West Sussex BN14 8JP
*Evangelism Today* – 320 Ashley Down Road, Bristol, Avon BS 9BQ

EVANGELISTIC MATERIAL
*News Special* – Challenge Literature Fellowship, Revenue Buildings, Chapel Road, Worthing, West Sussex BN11 1BQ
*Supertracts* and *Open Secret Bible study courses* – Christian Publicity Organisation, Garcia Estate, Canterbury Road, Worthing, West Sussex BN13 1BW
*Mark's Gospel* – The Bible Society, Stonehill Green, Westlea, Swindon, Wiltshire SN5 7DG
and Creative Publishing, Downwood, Claverton Down, Bath, BA2 6DT

STRING PRAISE TAPES – Maranatha Music, distributed by Word U.K.
Tearcraft – Tear Fund 100 Church Road, Teddington, Middlesex TW1 1 8QE
Traidcraft Ltd. Kingsway, Gateshead, Tyne & Wear NE11 0NE

DETAILS OF CHRISTIAN SOCIETIES
in *U.K. Christian Handbook* Edited by Peter Brierley (MARC-Europe)
Evangelical Alliance 186, Kennington Park Road, London SE11 4BT

Some of the chapters of this book are available as Project Sheets from Maranatha Ministries, Barras, Kirkby Stephen, Cumbria CA17 4ES. They are for use by individuals working together on these evangelistic projects.